ORSAY
Paintings

Michel Laclotte

Geneviève Lacambre

Claire Frèches-Thory

EDITIONS
SCALA

© Éditions Scala, 2000, 2003

Éditions Scala
Passage Lhomme
26, rue de Charonne
75011 Paris

Graphic design:
★ Bronx (Paris)

Cover:
Lagalerie

Layout:
Thierry Renard

Translation from French:
Judith Hayward

Corrections:
Scott Steedman

Diffusion – Distribution:
CDE - Sodis

CONTENTS

*Where the technique is not indicated,
the work is an oil painting;
the dimensions are given in centimetres.
The first exhibitions indicated were all held
in Paris.*

Painting First 5
Serge Lemoine

Introduction 7
Michel Laclotte

Eclectism and realism 23
Geneviève Lacambre

Impressionism 57
Claire Frèches-Thory

Post-Impressionism 89
Claire Frèches-Thory

Naturalism and symbolism 131
Geneviève Lacambre

After 1900 155
Claire Frèches-Thory

Index 166

Painting First

Serge Lemoine

Director of the Musée d'Orsay

The Musée d'Orsay, which is dedicated to the art of the second half of the nineteenth century and the turn of the twentieth, is known all around the world. Since its opening in December 1986 it has welcomed over 50 million visitors. It owes this extraordinary success in part to its position along the Seine, near the Louvre, and to its building, a converted 1900s railway station, but above all to its outstanding collections: paintings, sculptures, drawings, decorative art, works of architecture and photographs – each artistic discipline is displayed in keeping with its specific needs, each with the same care. Still, painting is Orsay's main attraction. The reason for this is simple: it is here that visitors can see works by some of the world's most famous artists.

Attention goes first to the ensembles: Courbet and Millet, who had an enduring influence, Corot and the School of Barbizon. The superb collection of Manets and the group of works by Fantin-Latour are impressive. Here too are the major works of Puvis de Chavannes, a painter whose heritage was felt well into the twentieth century. Monet, Pissarro, Renoir and Sisley, as well as Degas and Cézanne, are all represented by important ensembles, as are the artists of the next generation: Gauguin, Van Gogh and Toulouse-Lautrec, the Neo-Impressionists, Seurat, Signac and Cross, and the Symbolist movement with Moreau and Redon.

The period's other artistic trends are also shown. Whether Couture, Meissonier, Cabanel, Gérôme or Delaunay, or Breton, Tissot and Bastien-Lepage, or again Laurens, Detaille and de Neuville, many of these more academic artists enjoyed glory and held great authority during their lifetime. This panorama reflects the global pre-eminence then enjoyed by French art. By the same token, foreign artists are not so well represented, often only by one work: Whistler and Homer, whose paintings entered the collection back in the nineteenth century, or again Klimt, Hodler, Munch, Khnopff, Böcklin, Burne-Jones, Mondrian, Amiet and Hammershøi – all recent acquisitions and welcome extensions of the collection.

There are many paintings that stand out from these ensembles – universally celebrated masterpieces such as Millet's monumentally simple composition *L'Angélus*, or, in complete contrast, Renoir's *Le Bal du Moulin de la Galette, Montmartre,* with its shimmering touch and colours.

The Musée d'Orsay offers a particularly clear reflection of the effervescence of this period, which was one of the most creative in the history of art, and remains one of the most popular with the public. Its collection has grown continuously since it was first put together in the nineteenth century. At Orsay, the art of the period is presented in all its diversity, just as it is in this book.

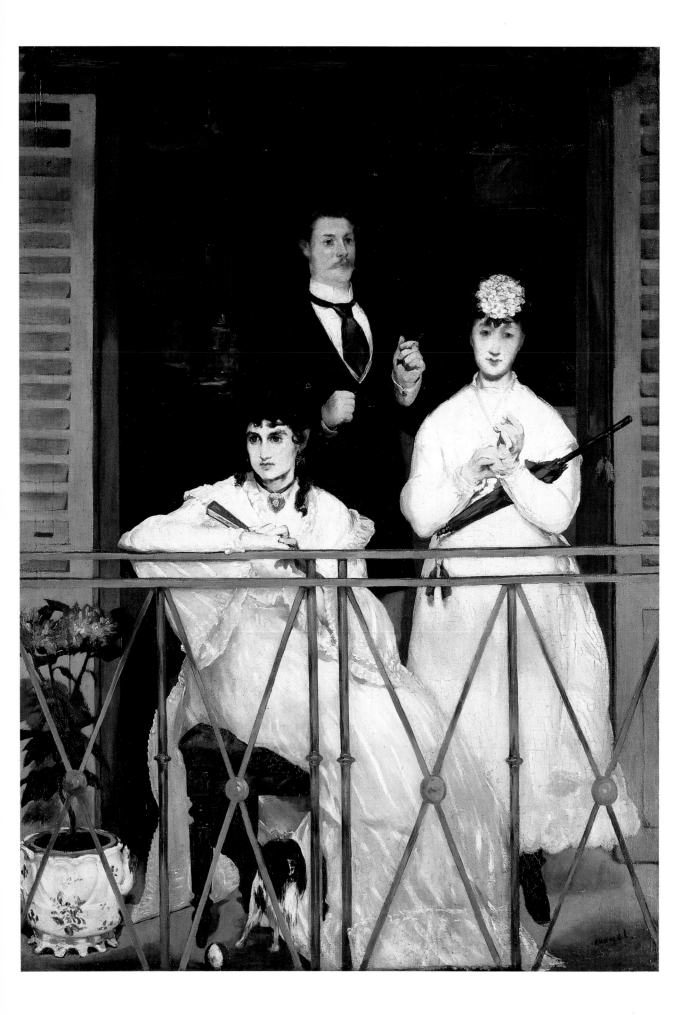

Introduction

The Musée d'Orsay offers a panorama of late 19th- and early 20th- century art. In addition, its programme of temporary exhibitions, concerts and audio-visual events lends itself to all forms of interdisciplinary encounters, stressing the complexity of an epoch which was incomparably rich in artistic experience and variety. To avoid confusion and surfeit, the planning of the museum's permanent exhibition rooms is clearly based on distinctions between techniques and modes of expression; hence, it is easy enough to plan and describe a general tour of the museum, linking the various display rooms while identifying each in a separate way. The aim of this book is to define such a tour, and at the same time to offer a history of painting from about 1850 to the early years of the 20th century, as illustrated by the collections of the Musée d'Orsay.

Before we go into the history of these collections, we should perhaps explain the timespan covered by the museum's programmes. This timespan is circumscribed by the Louvre on one side and the Musée National d'Art Moderne on the other.

The latter borderline is one that obtrudes quite naturally, in that the Musée d'Orsay ends where the Musée d'Art Moderne begins, in the tumultuous years of 1904-1907 which saw the birth of a completely new pictorial language in fauvism and expressionism, schools which were themselves nurtured by the post-Impressionist experience prior to the stunning challenge of the *Demoiselles d'Avignon* (1907). One might add that these years also saw radical changes in architecture and design, with the decline of Art Nouveau as a standard; for example, the Wienerwerkstätte were created after 1903.

It was less easy, however, to determine a preliminary date for a cut-off within the monolithic 19th century. The year of the Salon des Refusés, 1863, has sometimes been quoted as a suitable juncture; but in fact 1863 was only really important in terms of French painting, and represents no break in continuity where the other arts are concerned. A further step backward to include the

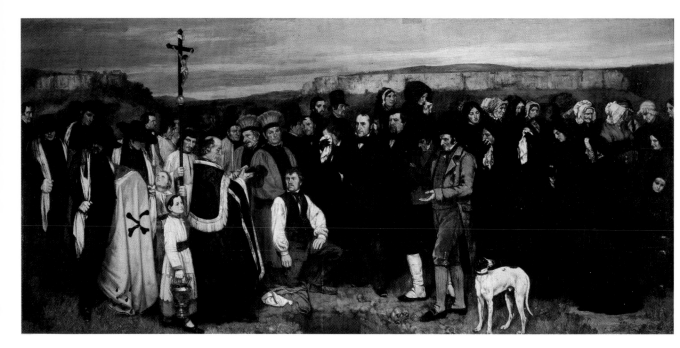

Romantic period, which was another possibility, would have required more hanging space than the Musée d'Orsay could supply (in particular for huge canvases like those of Gericault, Delacroix and the Louis-Philippe painters). Thus the decision was taken to set the museum's early limit at 1848-1850, a time which was redolent of change in every sphere and not only in the political, economic and social ones.

This timeframe contains the public recognition of Millet and Courbet, and with them of "realism", at the Salons of 1849 and 1850-1855; the foundation of the Pre-Raphaelite Brotherhood in 1848; and the construction of the Crystal Palace (1850-1851) and the Nouveau Louvre (from 1852 onwards). The essential role of the first universal exhibitions (London, 1851, Paris, 1855) in the development of historic eclecticism and the confrontation between art and industry was yet another aspect that marked a fundamental mid-century renewal in every area of artistic creativity.

To mitigate the arbitrary effect of this cut-off date, a certain amount of transitional leeway has been allowed. The first exhibition rooms contain a few later works by great artists of 1800-1850 who continued to be active and influential in succeeding years. These include Ingres and his school, Delacroix, Chassériau, Corot, Theodore Rousseau and the Barbizon landscape painters, the bulk of whose production nonetheless remains in the Louvre.

Likewise, the end of the period makes a brief allusion to fauvism, the development of which is taken up fully in the first "chapter" of the Musée d'Art Moderne.

The principal source of the collections which are today assembled at the Musée d'Orsay was the Musée du Luxembourg, founded in 1818 by Louis XVIII to house "the paintings and sculptures of the modern school". Until the creation of the Musée National d'Art Moderne in 1937, the Musée du Luxembourg contained a selection of state-owned works of art by living artists. The rule was that after the death of an artist "whose merit was endorsed by universal acclaim", his work would receive the supreme honour of entering the Louvre, after a period of purgatory which varied according to the times.

Hence the Musée du Luxembourg for years represented official taste, its only sources being the Salons; and the Salons in turn were the only vehicles by which an artist could make his work known to the public, on condition that he were admitted to them. In reaction to a period of openness to living art (Delacroix and Ingres were exhibited side by side from 1824 onwards), the criteria of selection narrowed considerably in the mid 19th century. After a liberal hiatus in 1848-1851, when Corot, Theodore Rousseau, Rosa Bonheur and Antigna were finally admitted (while Courbet's *Une après-dînée à Ornans* was acquired for the Musée de Lille), the Musée du Luxembourg reverted to a more limited view of contemporary art. This was personified by the more innocuous landscape artists and history and genre painters of reliable eclectic quality. Ignored, of course, were the strongest representatives of realism: the exclusion, in their lifetimes, of Courbet and Millet demonstrated a narrowness of outlook which naturally devolved onto the younger school headed by Manet.

Despite the efforts of its remarkable curator, Philippe de Chennevières, who became director of the Ecole des Beaux-Arts in 1873 (after trying in vain to acquire Courbet's masterpiece *Le Combat de cerfs* in 1861), the Luxembourg remained firmly opposed to new ideas throughout the 1870s and 1880s, although the purchase of works by Millet (1875), Diaz (1877) and Daubigny (1878) finally introduced some of the great older painters who had been neglected or bypassed.

The posthumous rehabilitation of Corot, Courbet, Millet and the Barbizon painters was carried out at the Louvre, its first manifestations being the acquisition of a number of

<

**Gustave Courbet
(1819-1877)**
Un enterrement à Ornans
1850-1851 Salon

Canvas
315 × 668
Gift of Mlle Juliette Courbet,
1881
R.F. 325

∨

**Jean-François Millet
(1814-1875)**
L'Angélus
1857-1859

Canvas
55.5 × 66
Alfred Chauchard bequest, 1909
R.F. 1877

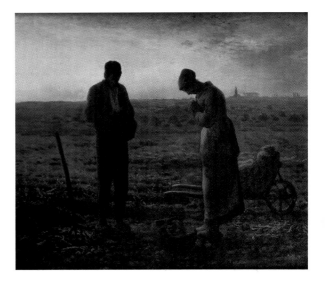

Courbets at auction and the gift of his *Enterrement à Ornans* by his sister. After this, the museum was presented with private donations of very fine works (Millet's *Printemps,* given by Mme Hartmann in 1887, and *Des Glaneuses,* given by Mme Pommery in 1880 when the artist's popularity was at its height), along with several complete collections.

The Louvre was also enriched by the collection of Thomy Thiéry, an art lover from Mauritius who had taken up residence in France. This copious and immaculately chosen group of paintings includes works by the Barbizon masters, as well as Corot and Delacroix. Rather than break up the unity of the ensemble, it was decided that the Thiéry collection should be kept intact at the Louvre and not moved to the Musée d'Orsay; in any case, most of the artists represented belong to the Louvre's allotted timespan. The presence of a few artists who properly belong in the Musée d'Orsay (such as Millet and Daubigny) will enable visitors to the Louvre to establish the necessary links between the 1830 school, the Barbizon school and their realist successors.

To achieve the reverse manoeuvre, i.e. to provide an adequate representation of the Barbizon painters at the Musée d'Orsay, a similar collection is exhibited there, that of

∨
**Édouard Manet
(1832-1883)**
Olympia
1865 Salon

Canvas
130.5 × 190
Gift to the state through public subscription instigated by Claude Monet, 1890
R.F. 644

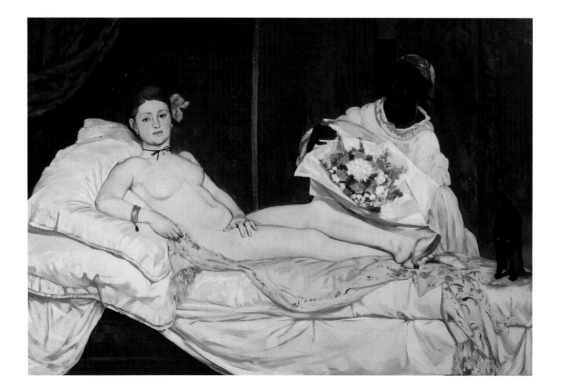

Alfred Chauchard, one of the founders of the Magasins du Louvre department store. The costly Chauchard collection, which entered the Louvre in 1909, is typical of the taste of many wealthy French and Americans of the time (apart from Thorny Thiéry, we may cite the collectors of Rheims, who left a magnificent legacy to their city). To Alfred Chauchard belongs the distinction of bringing Millet's *Angélus* home from America, at the then exorbitant price of 800,000 francs. His collection at the Musée d'Orsay offers a magnificent ensemble of works by Millet, the Barbizon school, Corot, Delacroix, Decamps and Meissonier.

Chennevières had dreamed of giving wall space to Manet and his pupils, as he did for Puvis de Chavannes. Of course, this project was never realized, and Manet did not receive the blessing of the Luxembourg in his lifetime, any more than Courbet or Millet. All the same, the first battle to open the museum to the Impressionists was waged in his name. In 1890 *Olympia* was purchased from Mme Manet, who was preparing to sell it to an American collector, by a group of subscribers organized by Monet. The painting was subsequently donated to the state and the Musée du Luxembourg. The following year, another classic masterpiece of modern art, Whistler's *Mother,* was bought by a similar group which included Mallarmé and Clemenceau. By contrast, the first Renoir to enter the museum, *Jeunes filles au piano,* was a recent work, practically done to order. This painting arrived in the same year, 1892, that the images of Monet, Bazille and Renoir himself appeared at the Luxembourg, grouped around Manet in Fantin-Latour's *Atelier des Batignolles.*

With the 1896 bequest of the painter Caillebotte, their friend and patron, the Impressionists finally reached the Luxembourg in force: seven Degas pastels, two Manets (one being *Le Balcon),* two Cézannes, eight Monets, six Renoirs (including *Le Moulin de la Galette),* six Sisleys and seven Pissarros.

But this invasion was not accomplished without difficulty, and only a part of Caillebotte's collection was ultimately accepted. The *affaire Caillebotte* caused, and still causes, considerable controversy. It has been recognized as convincing proof of the blindness of officialdom to living art. Even though this judgement may be tempered to some extent and certain functionaries can be excused (the national committee of museum curators did, after all,

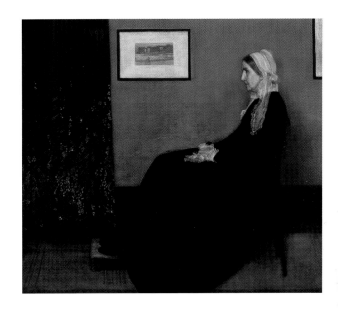

∧
James A. McNeill Whistler (1834-1903)
Arrangement in Grey and Black: Portrait of the Artist's Mother
1871

Canvas
144.3 × 162.5
Purchased in 1891
R.F. 699

accept the entire bequest), the fact remains that those responsible for the national collection rejected no less than twenty-nine paintings by Cézanne, Manet, Renoir, Sisley and Pissarro, and subsequently continued to reject them despite the entreaties of Martial Caillebotte. In 1897, the opening of a room devoted to Impressionist works from the Caillebotte bequest, in an annex of the Orangerie (opened as part of the Luxembourg in 1886), prompted an official protest from the Academie des Beaux-Arts. The Academie was incensed that paintings "flawed to the point of extravagance" could be hung alongside "the finest examples of contemporary French art".

Throughout the final third of the 19th century, the Musée du Luxembourg collection was regularly and abundantly expanded by purchases at the Salons and by gifts. The painters selected were not all conservative, as is proven by the acquisition of works by Fantin-Latour, Puvis de Chavannes, Carrière and later by the younger artists of the Bande Noire, to cite only a few examples. Nonetheless, the museum is dominated by ancient and modern historical paintings with exemplary subject matter, fashions and society portraiture, and naturalist paintings. Naturalist art, with sources of inspiration ranging from the populist to the symbolic, evolved clear and often brilliant modernist techniques of its own, eventually accounting for the bulk of late 19th century output outside avant-garde circles.

At this point, thanks to the labours of its curator, Léonce Bénédite, the museum was finally opened to non-French schools of painting, with many foreign artists following Whistler's pioneering example. Doubtless it will be regretted that such painters as Munch, Ensor, Hodler, Klimt and Segantini were overlooked, but at the same time rare works such as Winslow Homer's *Summer Night* (1900) and a remarkable series of Italian canvases by Pelizza da Volpedo (1910) were found and acquired. After a gift of several British paintings by Edmund Davis (1915), the foreign section of the Luxembourg had enough individual works (420) to warrant the opening of a separate museum at the Jeu de Paume in 1922.

Meanwhile, two generous collectors had endowed the Louvre, and the French national heritage, with Impressionist paintings of the very highest quality. The first of these benefactors was Etienne Moreau-Nelaton

>
**Vincent Van Gogh
(1853-1890)**
L'Arlésienne, Mme Ginoux
1888

Canvas
92 × 73
Donation with reservation
of lifetime use from Mme R.
de Goldschmidt-Rothschild,
announced August 1944;
entered collection in 1974
R.F. 1952-6

(1859-1927), whose work on Corot, Delacroix, Millet and Manet places him among the finest art historians of his time. His donation of paintings, complemented at his death by a large series of drawings by Corot, Delacroix and Millet, make up a unique ensemble of the 1830 school (this part of the collection has remained at the Louvre). In addition, there was Fantin-Latour's *Hommage à Delacroix,* and major works by Monet, Sisley, Pissarro and Manet, dominated by the *Déjeuner sur l'herbe.* The collection was presented to the Musée des Arts Décoratifs in 1906, and moved to the Louvre in 1934.

The collection of Comte Isaac de Camondo (1851-1911), a banker and lover of 18th-century French art, was bequeathed to the nation in 1911. It admirably completes and balances the Caillebotte and Moreau-Nelaton

collections with a sumptuous series of Degas, some late Monets, five Cézannes, and the first Lautrecs and Van Goghs acquired by the museum, in addition to works by the masters mentioned earlier.

Thenceforward, the Impressionists were officially accepted. The Luxembourg collection continued to grow, chiefly by dint of private generosity. This took the form of gifts by artists' heirs (Caillebotte, 1894; Toulouse-Lautrec, 1902; Renoir, 1923; Bazille, 1924; Monet, 1930; Pissarro, 1930); gifts from models (Degas' Dihaus and Manet's Zolas); and, above all, gifts from collectors. In 1929, the transfer of the Impressionists to the Louvre marked the triumph of a school of painting whose fame gradually eclipsed that of all the other late 19th-century movements. When their time came, many former stars of the old Luxembourg found themselves refused admission to the Louvre, and they were subsequently dispersed around France.

The lack of means available to national museums between the two wars was all the more regrettable because the talents of the great art dealers and the demand created by collectors had by then flooded the French market with canvases by the innovators of the second half of the 19th century. These innovators were by now regarded as great masters, and included names like Courbet, Corot or Daumier alongside the Impressionists. Inevitably, many paintings went abroad, although some were retained at the 1918 Degas sale *(Sémiramis, La famille Bellelli)*, as well as Monet's *Les femmes au jardin* (1921) and Gauguin's *Le Cheval blanc* (1927). Courbet's *Atelier* was acquired in 1920 by public subscription, supported by the Amis du Louvre. Nonetheless, apart from these brilliant exceptions, the French national heritage suffered an irremediable loss with the departure of many paintings by Cézanne, Gauguin and Seurat, which French museums either could not, or would not, prevent.

In 1937, the Musée du Luxembourg was abolished and replaced by the Musée National d'Art Moderne at the Palais de Tokyo, which had been built for the Universal Exhibition. The Musée d'Art Moderne reopened after the war with its collections greatly enriched by Jean Cassou's aggressive policy of acquisition (purchases and gifts by artists). At that time it offered a panorama of modern art beginning in 1890, i.e. neo-Impressionism (without Seurat), the Pont-Aven school (without Gauguin) and the

<

Vincent Van Gogh (1853-1890)
La Nuit étoilée
Arles, 1888
Salon des Indépendants, 1889

Canvas
72.5 × 92
Donation with reservation of lifetime use from M. and Mme Robert Kahn-Sriber in memory of M. and Mme Fernand Moch, 1975; entered collection in 1995
R.F. 1975-19

nabis; certain aspects of fin-de-siècle art, such as produced by the painters of *la vie parisienne*, were also peripherally represented.

The reorganisation of the Louvre, which had begun before the war and continued after 1946, produced one spectacular innovation. The Jeu de Paume took up the Louvre's Impressionist collections, from Boudin, Jongkind and Guigou to Seurat, Lautrec and the Douanier Rousseau. After the dark war years, the opening of the Impressionist museum in 1947 in the glorious light of the Tuileries had a symbolic effect at a time when younger artists were yearning for pure painting.

The ensemble of collections on exhibition is impressive, with a number of undispersed groupings that illustrate the taste of certain great benefactors (such as the collection of Antonin Personnaz, rich in Monets, Pissarros and Lautrecs, which was given in 1937). Its abundance, we repeat, is wholly due to the unselfishness and sense of civic obligation of art patrons, too numerous to name; but we should at least mention the magnificent gesture of Mme de Goldschmidt-Rothschild, who sent a telegram to the Directeur des Musées de France on the day of the liberation of Paris, to announce her intention of leaving her most precious possession, Van Gogh's *Arlésienne,* to the Louvre.

Fortunately, an increased budget support from the Amis du Louvre and revenue from an anonymous Canadian donor (linked to the memory of the Princesse de Polignac, who in 1943 bequeathed her paintings by Monet and Manet) allowed the museum to make certain vital purchases in the following years (notably works by Seurat, Cézanne and Redon). Other art lovers, meanwhile, gave their finest pieces (J. Laroche, 1947; Dr and Mme A. Charpentier, 1951; M. and Mme Frédéric Lung, 1961; baronne Gourgaud, 1965). The peace treaty with Japan brought some remarkable pieces from the Matsukata collection (1959). Finally, three entire new collections entered the Jeu de Paume: those of Dr Gachet, with eight Van Goghs (1949-1954); Eduardo Mollard (1961); and Max and Rosy Kaganovitch (1973), extending from Daumier to Derain.

As a result of this torrent of new paintings, the Jeu de Paume premises became too small for the large crowds of visitors which came flocking to see them and could no longer provide conditions of comfort and security. Thus

when the old Gare d'Orsay was classified a historic building and its demolition averted, the decision was made in 1977 to install a new museum there, covering the art of the second half of the 19th century and the beginning of the 20th, i.e. Impressionism and post-Impressionism. At a stroke, this solved the problem created by the Musée d'Art Moderne's move to the Centre Pompidou in 1976, which had resulted in the rejection of a number of works considered too old to merit a place in its programme. These included the paintings of the Pont-Aven school, the neo-Impressionists, the nabi group and a mass of fin-de-siècle French and foreign artists who had been kept in reserve for many years and whom both the history of art and contemporary fashions were now bringing back into favour. Hence the Musée d'Orsay is composed of the Jeu de Paume collections, the collections left at the Palais de Tokyo by the Musée d'Art Moderne (exhibited between 1977 and 1986 as a pre-figuration of the Musée d'Orsay, under the banner of post-Impressionism) and, lastly, paintings from the Louvre from the second half of the 19th century which were not displayed at the Jeu de Paume.

Yet, even assembled under one roof, it was doubted that the new Orsay collections would suffice to give a true idea of this extraordinarily fertile era. We know only too well how much our views of 19th-century art have altered in the last twenty-five years. For example, a series of rediscoveries and reassessments at *Les Sources du vingtième siècle* – a memorable exhibition organized in Paris in 1961 – brought to light the modernist trends linked to symbolism and Art Nouveau. Also revealed were the merits of certain artists hitherto unjustly condemned as frumpy and conventional, along with a number of other European and American painters who had long been overshadowed and excluded by the French school.

In consequence, a vigorous acquisition policy was initiated in 1978 with a view to balancing Orsay's motley collections, strengthening some sections and filling gaps in others wherever possible.

Since that date, about a thousand new paintings have entered the museum. In the first instance, these were works that already belonged to the national collections, recovered from various public premises (museums and administrative buildings) where they had come to rest, either because of

the somewhat incoherent dispersion of the Luxembourg collection between the wars or through the direct attribution of the Service des Œuvres d'Art de l'État.

This tactic produced a harvest of about thirty paintings, which were of course replaced by other works of art, according to the wishes of the curators concerned. These paintings mainly served to reinforce the selection of realists between 1848-1860 (Breton, Antigna, Pils, Jacque, Troyon, Vollon), certain aspects of Second Empire "eclecticism" (Tissot, Legros, Cabanel) and the official art of the Third Republic (Lhermitte, Gervex, de Neuville, Weerts, Henri Martin). The national museums (Compiègne, Fontainebleau) also contributed, with Versailles generously offering a valuable series of portraits (Hippolyte Flandrin, Baudry, Bonnat, Sargent, Meissonier, Forain). To the Musée des Arts Décoratifs we owe Maurice Denis' painted decoration for the Chapelle du Vesinet. Two other decorative ensembles were saved from an uncertain fate and restored: one by Luc-Olivier Merson for the stairway of a private townhouse (1901) and the other a grandiose mythological sequence painted by René Ménard for the Paris Law Faculty.

The second source of the museum's enrichment has been the generosity of private citizens, in some cases supported by the recently established Société des Amis du Luxembourg (Association of Friends of the Luxembourg) or by the Lutèce Foundation. Among the many gifts received by the museum we should mention a few presented by heirs of artists, which have resulted in a better representation of the work of Serusier (the Boutaric legacy), Mucha (the gift of Jiri Mucha, 1979), Cappiello (the gift of Mme Cappiello, 1981) and above all Odilon Redon, ostracised for so long by French museums (the gift of Ari and Suzanne Redon, 1984, of 542 individual works, including 91 paintings and pastels).

Thanks to regular purchases since 1904 (Vuillard, *Le Déjeuner du matin*) and donations (Vuillard, 1941, with many works by the artist; Reine Natanson; Bernheim de Villers, with family portraits by Bonnard, Vuillard and Renoir, etc.) the nabis were already very well represented in the original collection of the Musée d'Art Moderne. Bonnard's nabi period is incomparably demonstrated at the museum, as a result of an opportune series of donations (notably *La Partie de croquet*, given by Daniel

<
**Odilon Redon
(1840-1916)**
Le Char d'Apollon
1905-1914

Pastel and oil on canvas
91.5 × 77
Donation in lieu of payment
of death duty, 1978
RF 36724

Wildenstein through the Association of Friends of the Musée d'Orsay; *Garden,* given by Jean-Claude Bellier; and *Portrait de Claude Terrasse,* given by his son Charles) and *dations*, donations in lieu of payment of death duty *(Femmes au jardin).*

The museum has benefited from a particularly glittering series of donations in lieu of payment of death duty, which have enriched its entire repertoire. These range from Courbet *(La Truite, Femme nue au chien)* to Matisse *(Luxe, calme et volupté),* Manet *(Combat de taureaux, Évasion de Rochefort),* Monet *(La Rue Montorgueil, Jardin à Giverny),* Pissarro, Renoir *(Danse à la ville,* paired with *Danse à la campagne,* purchased in 1979) and Redon *(Eve,* and two pastels, *Vitrail* and *Le Char d'Appollon).* In 1982, the series of five Cézannes which were originally in the collection of Auguste Pellerin rejoined those with which the generosity of this great art lover and his children had already endowed the museum: three still lifes (1929), *Femme à la cafetière* (1956) and *Achille Emperaire* (1964). Though it naturally does not fail to include great works which would otherwise have left France (such as Monet's *La Pie),* the Musée d'Orsay's purchasing programme until its opening was intended to give priority to artists who were ill-represented, or represented not at all, in the collections. Hence a particular though still insufficient effort has been made in regard to foreign schools (Klimt, Munch, Böcklin, Burne-Jones, Khnopff, Strinberg, Stuck, Breitner, etc.).

As far as France is concerned, the museum is above all trying to strengthen its inventory of older masters from the Louvre (Ingres, *Venus*; Delacroix, *Chasse aux lions*; Huet; Isabey, *Saint Antoine,* given by the Association of Friends of the Musée d'Orsay). In addition, it is seeking to develop certain areas that have been neglected since the war, notably neo-Impressionism and the school of Pont-Aven. A stimulus had already been given to the first of these schools by the generosity of Ginette Signac (Signac, Cross, Théo van Rysselberghe); this was followed by the purchase of works by Signac, Luce, Théo van Rysselberghe and Lemmen. As to Pont-Aven, after the 1977 purchase of Bernard's *Madeleine au bois d'Amour,* other works by Bernard and Serusier have come to the museum, notably *Le Talisman.*

When the Musée d'Orsay opened its doors in December 1986, could it have been said that the history it related was complete and objective? Certainly not. A museum

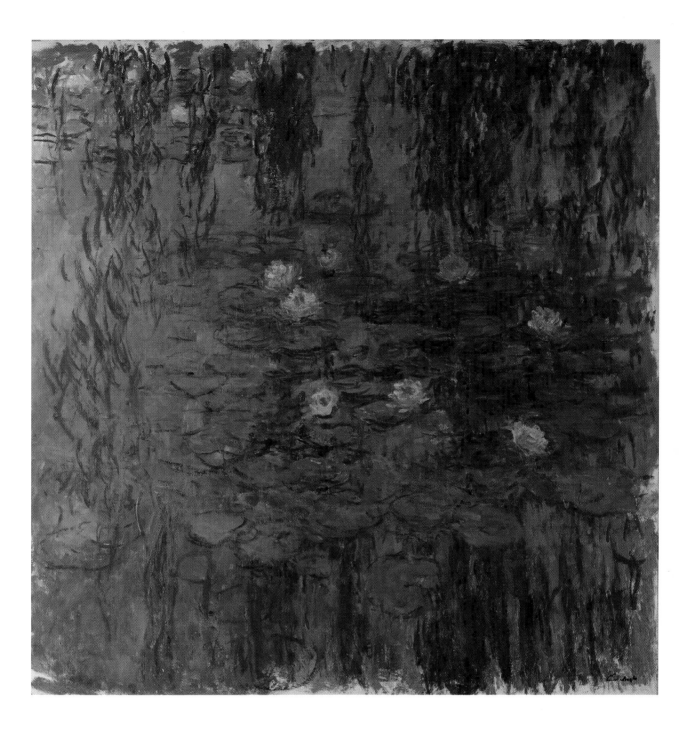

**Claude Monet
(1840-1926)**
Nymphéas bleus
c. 1916-1919

Canvas
200 × 200
Purchased in 1981
R.F. 1981-40

is not, and can never be, a coldly constructed ency-clopaedia, signed, sealed and delivered. It is bound to reflect the tastes and preferences of the people responsible for its gradual construction over the years. Many masters are still lacking, and many schools and movements in art – especially foreign ones – are scarcely even mentioned. Let us hope that the future will be rich in surprises and changes; and that by alterations, additions and subtractions we shall continue to perfect the reflection we offer today of an epoch in ferment, full of stimulating and fascinating contradictions.

Eclectism and realism

The new freedom glimpsed by artists in 1848 began to change their pictorial approach and challenge the hierarchy of genres and the artistic institutions. But there was some reticence.

∧
Amaury-Duval
(1808-1885)
Madame de Loynes
(1837-1908)
1862
1863 Salon

Canvas
100 × 83
Jules Lemaître bequest, 1914
R.F. 2168

<
Honoré Daumier
(1808-1879)
La République
Sketch submitted to the
competition opened in 1848 by
the directorate of the Beaux-Arts

Canvas
73 × 60
Étienne Moreau-Nélaton
donation, 1906
R.F. 1644

The days of February 1848, which brought down the July Monarchy, were of the highest political importance in that they ignited other revolutions all across Europe. 1848 also had immediate repercussions for artists, whose lives had previously been dominated by the Salon: because it was up to the jury of the Salon, which was composed of members of the Academie des Beaux-Arts, to make its choice among the works presented. The artists they favoured found themselves able not only to reach potential private buyers, but also to sell to the most prestigious public institution as far as art was concerned, the Musée du Luxembourg, which collected the best works of living artists. One of the first acts of the 1848 republican administration was to open a Salon at the Louvre without a jury; the experiment was not repeated, since the Salon attracted too many inexperienced amateurs, but it did allow a few ostracized artists like Courbet to become known. 1848 was also the year that the government organized a public competition for a figure symbolizing the Republic; this produced all kinds of paintings in the usual allegorical tradition, but among the twenty painted sketches which were selected for full-size execution was one by Daumier, then at the start of his career. As an enthusiastic republican, Daumier had produced a powerful rendering of the motto "The Republic feeds and educates its children". He was never to complete the larger version, but he kept the sketch, which finally entered the Louvre in 1906 as part of the Moreau-Nelaton donation. After 1848 there followed several years of support for a type of painting which had formerly been condemned, along with a reassessment of the hierarchical academy of genres. But despite a gradual reversion to traditional structures, particularly as far as the

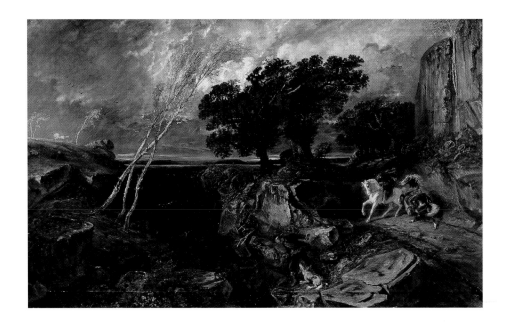

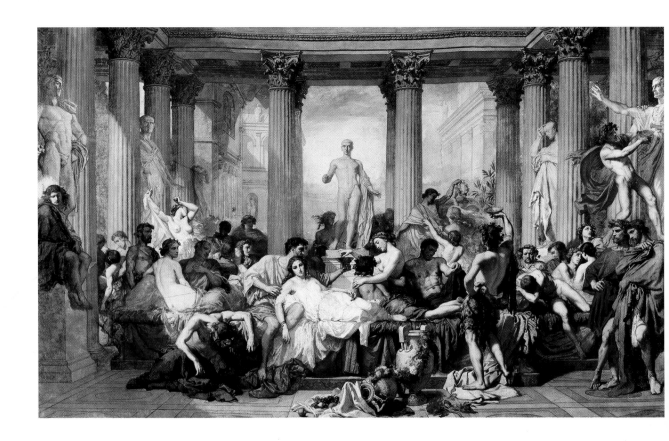

<
Paul Huet
(1803-1869)
Le Gouffre
1861 Salon

Canvas
125 × 212
Purchased in 1985
R.F. 1985-84

>
Jean-Léon Gérôme
(1824-1904)
Jeunes Grecs faisant
battre des coqs or
Un combat de coqs
1846
1847 Salon

Canvas
143 × 204
Purchased in 1873
R.F. 88

<
Thomas Couture
(1815-1879)
Romains de la décadence
1847 Salon

Canvas
472 × 772
Commissioned in 1846
INV. 3451

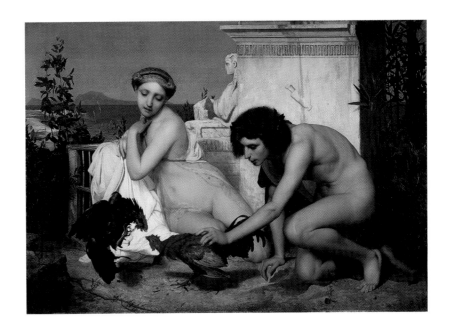

jury of the Salon was concerned, a real break did take place in many areas which subsequently affected the art of the Second Empire.

The first fruits of this had already begun to appear before 1848; where the painting of historical themes was concerned, the 1847 Salon was distinguished by the much-remarked late arrival of a huge composition by Thomas Couture (1815-1879), *Les Romains de la décadence*; this had been ordered by the administration in 1846, and was later exhibited in the Musée du Luxembourg in 1851. In the orgiastic theme of the painting and the attitudes of the figures (which were considered trivial at the time) we may detect the first stirrings of realism: nonetheless, the myriad references to the art of the past, including Veronese, Tiepolo and Poussin, make this a fine example of eclecticism, with its clear colours and broadly brushed, almost chalky architecture.

Nonetheless a smooth technique and carefully studied draughtsmanship, the legacy of the neo-classicism practised by David, persisted among the younger artists who were admirers of Ingres, known as Neo-Grecians. One of the most famous was Jean-Léon Gérôme, who was twenty-two years old when he painted *Un combat de coqs*, which attracted a lot of attention at the 1847 Salon. However Champfleury, an advocate of realism and a damning critic of what he called the "copybook school"

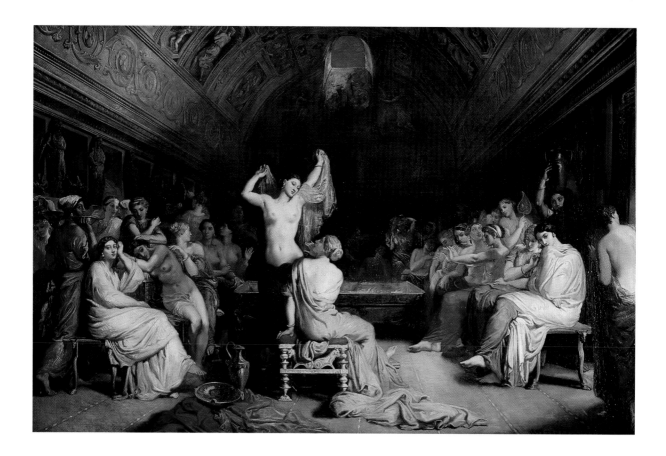

(*école de calque*), reproved the young artist for juxtaposing marble figures and cocks that were "flesh and blood ... painted from nature".

A perceptible move away from history painting towards genre scenes became apparent from the early days of the Second Empire. It was characterised by the use of semi-naturalistic figures in scenes with historical subjects. That is how the Musée du Luxembourg came to buy *Saint François* by Bénouville and *Tépidarium* by Chassériau at the 1853 Salon. In a setting inspired by the plates in Mazois's *Les Ruines de Pompéi* collection, Chassériau depicts a crowd of women who have come to dry off and rest in this room – heated by a brazier – in an antique bathing establishment. They are languid and graceful in a very Orientalist manner. To some extent it is a response by Chassériau, a pupil of Ingres who was attracted by Delacroix's colour, to the romantic Orientalism which saw North Africa as providing a living vision of antiquity. He had visited Algeria in 1846 and his last work was to be a sketch of an *Intérieur de harem*.

These paintings would be exhibited again at the Palais des Beaux-Arts, a temporary building erected on the avenue Montaigne for the 1855 Exposition Universelle which Napoleon III decided to organize along the lines of the 1851 Great Exhibition at Crystal Palace which had

V
**Théodore Chassériau
(1819-1856)**
Sapho
1849
1850-1851 Salon

Wood
27.5 × 21.5
Bequest of Baron Arthur
Chassériau, 1934
R.F. 3886

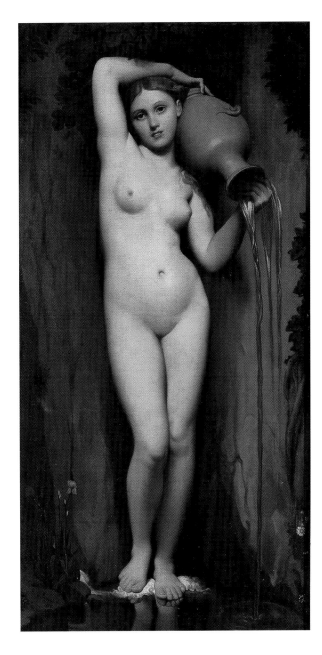

reflected glory on Queen Victoria and Prince Albert. By comparison with London, it was an innovation to ask living artists from all nations to take part in a retrospective exhibition; the result was a fabulous temporary museum filled with the art of the preceding decades. All the major paintings of Ingres and Delacroix, the two personalities who dominated the contemporary art scene, were displayed; and today, while most of their work remains in the Louvre, the Musée d'Orsay nonetheless possesses a few later pieces. Ingres, who had for years boycotted the Salon, sent some recent paintings to the Universal Exhibition, notably his *Vierge à l'hostie,* ordered by the state and completed in 1854. He completed *La Source* in 1856, the ownership of which was hotly contested by rich

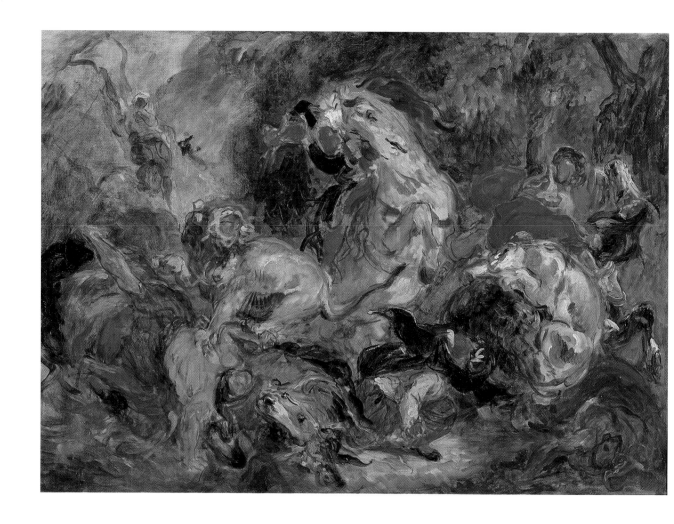

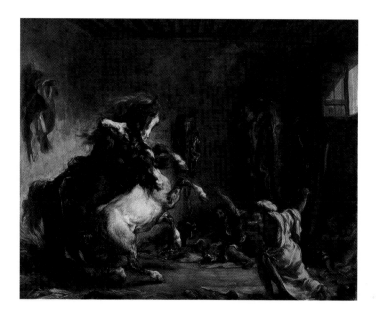

∧
**Eugène Delacroix
(1798-1863)**
Chasse aux lions
1854
Sketch for the picture commissioned
for Bordeaux museum, shown at the
1855 Universal Exhibition

Canvas, 86 × 115
Purchased in 1984
R.F. 1984-33

<
**Eugène Delacroix
(1798-1863)**
*Chevaux arabes se battant
dans une écurie*
1860

Canvas, 64.5 × 81
Bequest of Comte Isaac
de Camondo, 1911
R.F. 1988

collectors after a private viewing in his studio. The battle was eventually won by Comte Duchâtel, and in 1878 his widow bequeathed this painting, hailed at the time by Théophile Gautier as a masterpiece, a "pure Parian marble with the bloom of life", to the museums of France. Against Ingres, the undisputed master of line, stood Delacroix, the Romantic colourist. The sketch – acquired for the Musée d'Orsay – for the *Chasse aux lions* commissioned in 1854 and sent to Bordeaux following the 1855 Universal Exhibition is the clearest demonstration of this. Painted ardently in pure colours, the sketch remained in the artist's studio until his death, after which it was shown in a number of exhibitions and influenced many young painters, notably Manet, Renoir, Signac and Matisse.

The Musée du Luxembourg would always admit works by painters who completed their studies at the Ecole des Beaux-Arts, won the Prix de Rome, and then returned from Italy to enter the Academie des Beaux-Arts and receive their nomination as teachers at the Ecole. Thus Cabanel won the Prix de Rome in 1845, Baudry and Bouguereau in 1850, Delaunay in 1856 and Regnault in 1866. Regnault was Cabanel's pupil, and Cabanel, like Bouguereau, had been the pupil of Picot: thus an academic tradition was perpetuated, one which had begun with neo-classicism but which gradually lost its heroic subject matter and replaced it with pure fantasy.

∨
Paul Baudry
(1828-1886)
Charles Garnier, architect
1868
1869 Salon

Canvas
103 × 81
Bequest of Mme Charles
Garnier, the model's widow,
1922
R.F. 2363

∨ ∨
Franz-Xaver Winterhalter
(1805-1873)
Madame Barbe de
Rimsky-Korsakow,
the composer's aunt
1864

Canvas
117 × 90
Gift of her sons, Messrs Rimsky-
Korsakov, 1879
R.F. 235

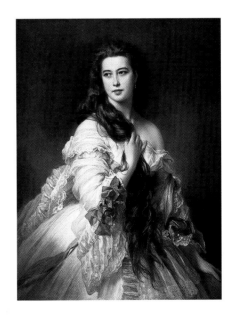

Although Cabanel was elected a member of the Académie des Beaux-Arts in 1863, the same year that his picture *La Naissance de Vénus* was bought by the emperor, the mythological composition based on fantasy did not go to the Musée du Luxembourg until much later, when a legal ruling was made regarding the civil list of Napoleon III in 1879. That same year Bouguereau who had already been a member of the Institut for three years exhibited his more spirited version of the same subject at the Salon, and it was immediately bought by the government for the Musée du Luxembourg. This academic art which was severely criticised by the press was soon to be replaced by an officially approved naturalism which was to prevail in the 1880s.

From early in the Second Empire mythological subjects were rivalled by those illustrating early Christianity – *La Peste à Rome* by Delaunay inspired by Jacques de Voragine's *Golden Legend* is one of the most accomplished examples – or medieval history. Henri Regnault, fascinated by Spain and Andalusia in particular, where he travelled before settling for a few months in Tangiers, set his last submission as a bursar in the Islam of the Middle Ages: the *Exécution sans jugement sous les rois Maures de Grenade* is iridescent in its colouring, and gory. The artistic world was dismayed to hear of the heroic death of this brilliant and promising painter at the battle of Buzenval during the siege of Paris on 19 January 1871.

Alexandre Cabanel
(1823-1889)
Naissance de Vénus
1863 Salon

Canvas
130 × 225
Acquired from Napoleon
III's Civil List in 1863 and
assigned to the national
museums in 1879
R.F. 273

>
Elie Delaunay
(1828-1891)
Peste à Rome (Jacques
de Voragine, *La Légende
dorée*, legend of
St Sebastian)
1869 Salon

Canvas
131 × 176.5
Purchased in 1869
R.F. 80

<
William Bouguereau
(1825-1905)
Naissance de Vénus
1879 Salon

Canvas
300 × 218
Purchased in 1879
R.F. 253

>
Henri Regnault
(1843-1871)
*Exécution sans jugement
sous les rois maures
de Grenade*
1870

Canvas
302 × 146
Purchased in 1872
R.F. 22

∧
Théodule Ribot
(1823-1891)
Le Samaritain
1870 Salon

Canvas
112 × 145
Purchased in 1871
R.F. 106

It was a different Spain, that of the painters of the golden age of Spanish painting, particularly Velasquez or Ribera, that inspired Ribot when he depicted *Le Samaritain* with a violent light falling on the body of the wounded man. It proved possible for this picture – which had been sent to Warsaw in 1931 and was believed to have been destroyed – to be returned to France in 1998, and it is now exhibited at the Musée d'Orsay.

Meissonier's detailed depictions of military life are part of an entirely different trend, nurtured by study of the Flemish and Dutch masters at the Louvre. He always

specialized in small formats, even for heroic compositions involving a faithful reconstruction of the uniforms of the time, as in *Campagne de France, 1814*. For this evocation of the most tragic year in Napoleon I's reign, Prince Napoleon had lent the painter a saddle that had once belonged to the emperor. The picture, started around 1860 and shown belatedly at the 1864 Salon, was soon sold to a banker for 85,000 francs, as the value placed on Meissonier's paintings was already remarkably high. He achieved the record for the century for a work by a living artist when the ultra-rich Alfred Chauchard paid 850,000 francs for one of his paintings in 1890, a little more than for Millet's *L'Angélus* which Chauchard bought for 800,000 francs at the same time.

v
**Ernest Meissonier
(1815-1891)**
*Campagne de France,
1814*
1864 Salon

Wood
51.5 × 76.5
Alfred Chauchard bequest, 1909
R.F. 1862

∧
**Pierre Puvis
de Chavannes
(1824-1898)**
L'Eté
1873 Salon

Canvas
350 × 507
Purchased in 1873
R.F. 1986-20

>
**Gustave Moreau
(1826-1898)**
Orphée
1865
1866 Salon

Wood
154 × 99.5
Purchased in 1866
R.F. 104

At the other end of the scale Puvis de Chavannes, inspired by the example of Italian primitive artists, set about renewing decorative painting on the walls of public buildings or in huge, luminous compositions: *L'Été* from the 1873 Salon, initially deposited at Chartres museum and brought back to Paris for the Musée d'Orsay, is an outstanding example of his wish to paint his characters in timeless costumes, presaging the idealistic symbolism of the end of the century.

The Austrian Makart with his decorative panels entitled *Abundantia* – another recent acquisition – is closer in register to traditional allegory.

At that time the Musée du Luxembourg devoted itself mainly to French art, very often holding only a single painting for each artist. This was the case with Gustave Moreau and his famous *Orphée* from the 1866 Salon. This poetic composition was elucidated in the Salon catalogue by this observation: "a young girl piously collects Orpheus's head and lyre which have been carried by the waters of the

Hebrus to the shores of Thrace". In it Moreau breaks with traditional iconography, as the Pre-Raphaelites were doing in Great Britain, already anticipating symbolism. Unsuccessful in the Prix de Rome competition, Moreau decided to complete his training by spending the period from 1857 to 1859 in Italy studying at his own expense, and while there he steeped himself in the art of the great Renaissance masters such as Michelangelo, Raphael and Leonardo da Vinci. He also made the acquaintance of the young Edgar Degas at that time. Although Degas tended to be more drawn to portraiture, under the influence of his mentor he initially turned to history painting based on antique subjects, as demonstrated by *Sémiramis construisant Babylone*. He avoids the theatrical historical reconstruction beloved of Academicians in the simplicity of the drapery, while introducing a few details – Semiramis's head-dress, the chariot on the right – inspired by the Assyrian works which had come to the Louvre a short time before. This painting, which the artist had kept in his studio, was one of the first bought for the Musée du Luxembourg at the sale of his estate in 1918.

∧
**Hans Makart
(1840-1884)**
*Abundantia;
les dons de la terre*
1870
Painted for the dining room
of the Hoyos Palace in Vienna
but not used

Canvas
162.5 × 447
Purchased in 1973
R.F. 1977-50

∨
**Edgar Degas
(1834-1917)**
*Sémiramis construisant
Babylone*
1861

Canvas
151 × 258
Purchased in 1918
R.F. 2207

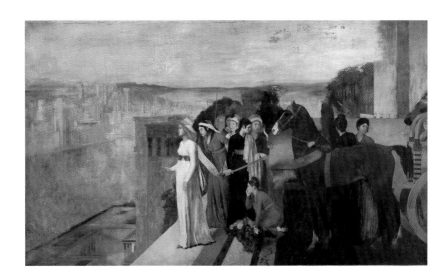

While older painters like Corot made several trips to Italy, prior to scouring the length and breadth of France in search of subject matter, others systematically abandoned this tradition in favour of a close study of the French countryside and the life of their native provinces.

In the end this guarantee of great art, identified by the academic guardians of eclecticism in constant references to the past, ceased to satisfy a certain breed of artists who preferred sincerity and direct observation of nature. Under Louis-Philippe, these artists were frequently barred from the Salon, but their moment of glory came under the short-lived Second Republic, when they gleaned such honours that they were subsequently exempted from submitting their works to the judgement of the jury, or even from exhibiting them – though for all that they still sold nothing to the Luxembourg.

This was the case of Millet and Courbet, some of whose paintings were timidly introduced to the Luxembourg soon after their deaths. 1875 witnessed the appearance of Millet's sober *Église de Greville;* and in 1878 *La Vague* by Courbet was exhibited, followed in 1881 by his two self-portraits, which had been purchased at auction after his death. The problem with both Millet and Courbet was that the administration was

∧
**Gustave Courbet
(1819-1877)**
La Mer orageuse
or *La Vague*
1870 Salon

Canvas
117 × 160.5
Purchased in 1878
R.F. 213

>
**Théodore Rousseau
(1812-1867)**
*Clairière dans la Haute Futaie;
forêt de Fontainebleau,*
known as *La Charette*
1863 Salon

Wood
28 × 53
Alfred Chauchard bequest, 1909
R.F. 1888

>
**Charles-François
Daubigny
(1817-1878)**
Moisson, 1851
1852 Salon

Canvas
135 × 196
Purchased in 1853
R.F. 1961

∧
Honoré Daumier
(1808-1879)
Crispin et Scapin
c. 1863-1865

Canvas
60.5 × 82
Gift of the Association of
Friends of the Louvre with
the assistance of the children
of Henri Rouart, 1912
R.F. 2057

∧
Honoré Daumier
(1808-1879)
La Blanchisseuse
c. 1860-1861

Wood
49 × 33.5
Purchased with the assistance
of D. David-Weill, 1927
R.F. 2630

shocked by their techniques and outraged by their choice of subjects.

While Daumier's astonishingly vigorous and modern paintings went almost unnoticed until the 1878 exhibition at the Galerie Durand-Ruel, those of the Barbizon painters (Theodore Rousseau, Diaz and Dupré), who had in some instances become famous before 1848, were aimed at a private clientele. A market for the Barbizon painters quickly developed, and became progressively better organized on an international scale. The idea was that the museum should offer serious art, fit to set an example to artists and bolster France's predominant position in the field. This could exclude from the Luxembourg the works of painters who might simultaneously be on the emperor's civil list (along with Cabanel, Courbet or Corot) or in the directorate of the Beaux-Arts for the provinces, or even in the civil service. Daubigny is an interesting case in point: for years he was represented at the Luxembourg by a stolid landscape of Optevoz (subsequently moved to Rouen). Yet his *Moisson* exhibited at the 1852 Salon, with its stunning horizon in pure, simply juxtaposed colours of red and yellow, was originally purchased for the premises of the Justice Ministry and only reached the Louvre in 1907.

∧

**Jean-François Millet
(1814-1875)**
*La Fileuse, chevrière
auvergnate*
1868-1869

Canvas
92.5 × 73.5
Alfred Chauchard bequest,
1909
R.F. 1880

∧ ∧

**Jean-François Millet
(1814-1875)**
Des Glaneuses
1857 Salon

Canvas
83.5 × 111
Gift of Mme Pommery, 1890
R.F. 592

Daubigny, like the Barbizon painters, was not afraid to take his easel out of doors and away from the cold northern light of the studio. In his boat, the *Botin,* he toured the rivers of the Ile de France and observed the reflections of light on water, as Monet later did. It is known, too, that Daubigny supported Manet's group of young naturalist painters as much as possible, after he was elected to the jury of the Salon in 1864.

Millet was also interested in landscapes, particularly after 1863. Since 1848, while adhering to the small genre format, he had contrived to elevate the representation of labour in the fields to the same status as that of historical themes. Thus he created a whole series of works in the vein of *Des Glaneuses* or *L'Angelus* which attained great celebrity after 1880 but which horrified conservative critics and inspectors from the Beaux-Arts under the Second Empire. All the same. Millet had no lack of admirers, especially after 1860; for example, Frédéric Hartman ordered a series of four seasons from him which was never completed – though we do possess *Le Printemps,* a painting of luminous, dewy freshness which delicately and symbolically blends the presence of man with the awakening of nature. Emile Gavet encouraged Millet to use pastel techniques, as in the stunning *Bouquet de marguerites* where he returns to the lightness of touch shown in his early work, but this time in the context of naturalism. This pastel, which was purchased at the 1875 Gavet sale by Henri Rouart, was an influence in the development of Degas, who was a friend of the Rouart family.

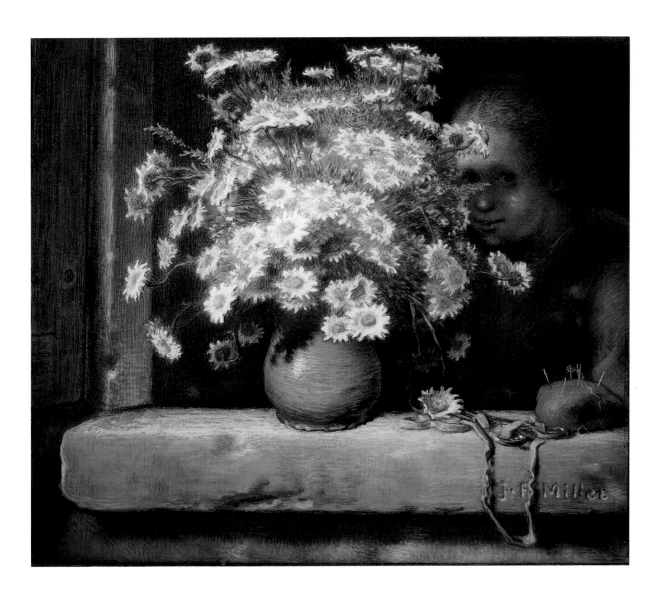

∧
**Jean-François Millet
(1814-1875)**
Le Bouquet de marguerites
1871-1874

Pastel on beige paper
68 × 83
Purchased with the
accumulated interest on
the Dol-Lair bequest, 1949
RF 29776

<
**Jean-François Millet
(1814-1875)**
Le Printemps
1868-1873

Canvas
86 × 111
Gift of Mme Frédéric Hartmann,
1887
R.F. 509

∧
∧

**Jean-Baptiste Camille
Corot (1796-1875)**
*Une matinée.
La Danse des nymphes*
1850-1851 Salon

Canvas
98 × 131
Purchased in 1851
R.F. 73

∧

**Jean-Baptiste Camille
Corot (1796-1875)**
L'Atelier de Corot
c.1865-1866

Canvas
56 × 46
Purchased with the assistance
of Mme Hubert Morand, 1933
R.F. 3745

The lack of connection between the attitudes of the public and the artistic community, on the one hand, and that of the administration, with its high sense of its own mission, on the other, is highlighted by the misfortunes that befell the only painting by Corot that entered the Musée du Luxembourg in his lifetime, in 1854: *Une matinée – La Danse des nymphes.* For the 1850-1851 Salon, Corot had taken the precaution of including a few nymphs in his *Matin,* a misty evocation of a site on the Palatine Hill at Rome which he had seen as a young man. That year, Corot himself was appointed to the jury; nonetheless, the staff of the Salon placed his painting in reserve, as though it had been damaged. Following a protest by one of the painter's friends, the painting was retrieved and acquired as a gesture of courtesy by the directorate of the Beaux-Arts, which was subsequently in no hurry to find a home for it. Finally, on the insistence of Philippe de Chennevières, it was admitted to the Luxembourg when Corot was fifty-eight.

Although Courbet courted scandal vigorously in the first years of the Second Empire (in 1855 he responded to a partial rebuff from the jury of the Universal Exhibition by opening a private pavilion at the Alma under the banner of realism), nonetheless his most cherished desire was for recognition. Like other artists of the time, such as Jules Breton or Alexandre Antigna, he undertook large paintings with life-size figures to depict contemporary, everyday subjects; but his goal in doing so was to gain for his sincere and modern view of art the pre-eminent respect hitherto accorded to historical painting. The logical consequence was that *Un enterrement à Ornans, L'Atelier,* and *Le Combat de cerfs,* his largest paintings, found no buyers in his lifetime. Nor did *Le Départ des pompiers courant à un incendie,* which is now at the Petit Palais.

In December 1849, encouraged by his success at that year's Salon – he had been awarded a medal and his painting was bought by the government for Lille museum – Courbet embarked on a huge composition, *Un enterrement à Ornans,* getting some fifty of the inhabitants of his native town to pose for it from the end of the summer. It was his first truly monumental work depicting a commonplace, familiar episode, the country burial of an unknown person. While he seems to draw inspiration from both Spanish art and the large collective

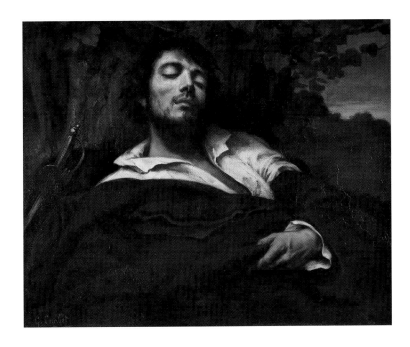

<
**Gustave Courbet
(1819-1877)**
L'Homme blessé
1844

Canvas
81.5 × 97.5
Purchased at the sale
of the artist's studio, 1881
R.F. 338

v
**Gustave Courbet
(1819-1877)**
*L'Atelier du peintre.
Allégorie réelle*
1854-1855

Canvas
361 × 598
Purchased with the help of a public
subscription and the Association of
Friends of the Louvre, 1920
R.F. 2257

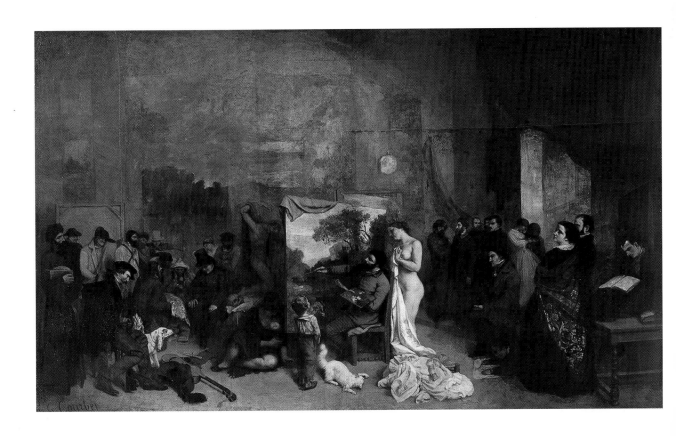

portraits made by the Dutch in the 17th century, at the same time Courbet confirms his desire for realism, even in treating a subject as sacred as death.

A few years later he launched into another large-scale project, *L'Atelier du peintre*, in which he staked his own position in the society of the day among his friends – including the writers Baudelaire and Champfleury and Bruyas, a patron of the arts – and the coded representatives of the political scene, from revolutionaries to Napoleon III, dressed as a hunter. In the centre Courbet himself is painting nature, proving that, though he was accused of "painting ugly things", he knew how to handle a child, a cat, and the naked model who symbolically keeps watch behind him in a graceful manner.

Courbet could be charming in boudoir scenes like *Femme nue au chien*, but equally did not shirk from painting the daring nude *L'Origine du monde* for Khalil Bey, a Turkish art-lover then living in Paris. This painting, which remained hidden for a long time, recently entered the Musée d'Orsay through a donation in lieu of payment of death duty.

v
**Gustave Courbet
(1819-1877)**
Femme nue au chien
1861-1862

Canvas
65 × 81
Donation in lieu of payment
of death duty, 1979
R.F. 1979-56

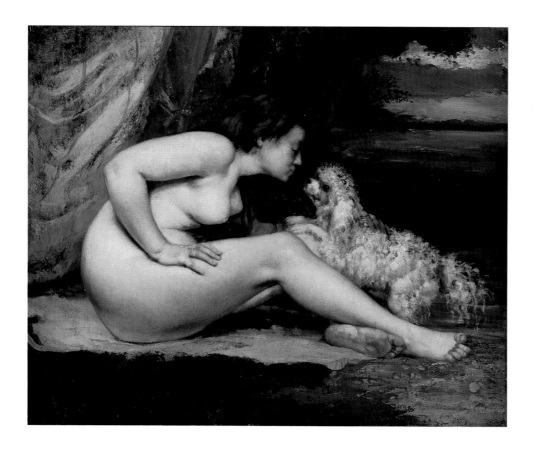

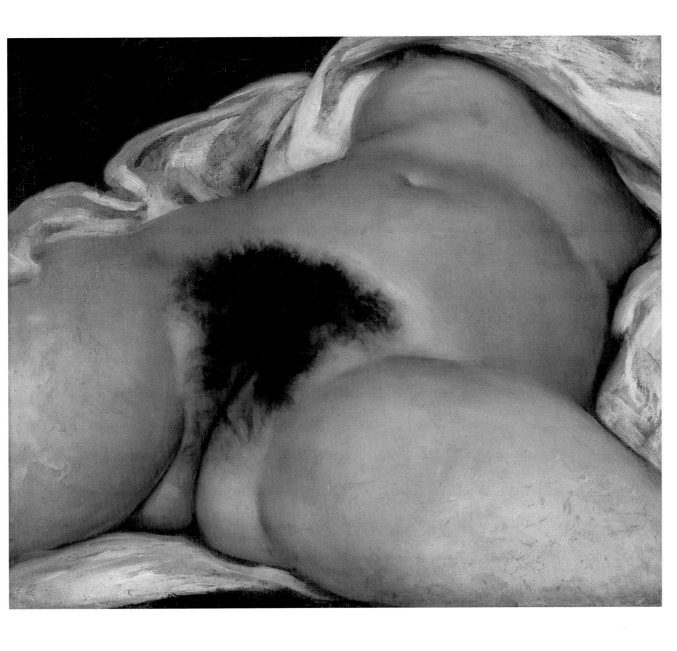

∧
**Gustave Courbet
(1819-1877)**
L'Origine du monde
1866

Canvas
46 × 55
Donation in lieu of
payment of death
duty, 1995
R.F. 1995-10

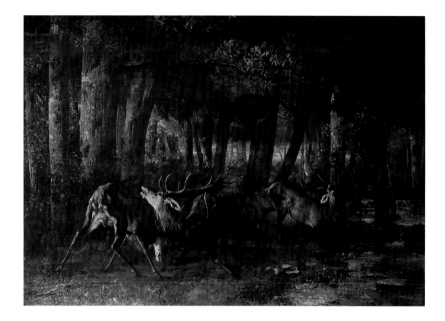

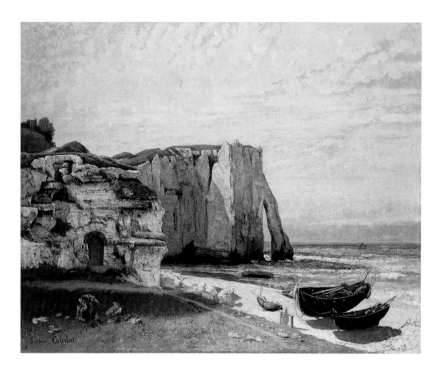

<
**Gustave Courbet
(1819-1877)**
*Le Rut du printemps.
Combat de cerfs*
1861 Salon

Canvas
355 × 507
Purchased at the sale
of the artist's studio, 1881
R.F. 326

>
**Paul Guigou
(1834-1871)**
Lavandière
1860

Canvas
81 × 59
Gift of Paul Rosenberg, 1912
R.F. 2051

>>
**Alfred Stevens
(1823-1906)**
*Ce qu'on appelle le
vagabondage,* also
known as *Les Chasseurs
de Vincennes*
1855 Universal Exhibition

Canvas
130 × 165
Léon Lhermitte bequest, 1926
INV. 20847

<
**Gustave Courbet
(1819-1877)**
*La Falaise d'Étretat
après l'orage*
1870 Salon

Canvas
133 × 162
Assigned by the Office
des Biens Privés, 1951
M.N.R. 561

>
**Eugène Boudin
(1824-1898)**
La Plage de Trouville
1864

Wood
26 × 48
Eduardo Mollard donation,
1961
R.F. 1961-26

His native region of Franche-Comté also inspired him to paint damp undergrowth teeming with does and stags. He also spent some time on the coast of Normandy, where in 1870 he painted the sea and cliffs of Étretat with unusual power. Courbet's involvement in the Commune forced him to leave France and disappear from the artistic scene just as Impressionism was getting under way. Bringing works that were previously held separately by the Louvre and the Jeu de Paume together in the rooms of the Musée d'Orsay has

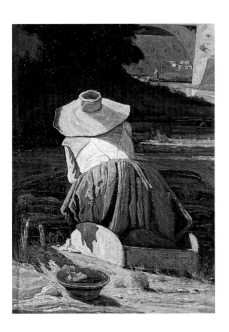

enabled us to measure the debt the young artists of this movement owe him.

The role of discreet instigator that the Norman landscape artist Eugène Boudin played for Monet is well known; Boudin knew how to convey the changing light of the sky and the bustle of the seaside in the new holiday resorts of the Second Empire period, as in *La Plage de Trouville*. These are a far cry from the intentionally poverty-related subjects of the 1850s, such as *Ce qu'on appelle le vagabondage*, by the Belgian artist Alfred Stevens.

>
Jules Breton
(1827-1906)
Le Rappel des glaneuses,
Artois
1859 Salon

Canvas
90 × 196
Acquired from Napoleon III's
Civil List in 1859 and
donated in 1862
M.I. 289

v
Rosa Bonheur
(1822-1899)
Labourage nivernais;
le sombrage
1849 Salon

Canvas
134 × 260
Commissioned in 1848
R.F. 64

Speaking on behalf of all those who rejected academic teachings, Castagnary, the chief theoretician of naturalism, wrote in his *Philosophie du Salon de 1857*: "Nature and man, portraiture and genre painting – in these lie the whole future of art" and boasted of "the free inspiration of the individual".

This free inspiration took the form of a search for a new way of painting, in which the matter would be visible, generously applied, and no longer mellow and smooth. All variations were possible and Jules Breton and Rosa

<
François-Louis Français
(1814-1897)
Le Mont-Blanc, vu de
Saint-Cergues (Jura)
1869 Salon

Canvas
128 × 162
Gift of the Association
of Friends of the Musée
d'Orsay, 1990
R.F. 1990-12

Bonheur were immediately successful, like the advocates of naturalist Orientalism, Fromentin and Guillaumet. But many others had a harder time of it; Chintreuil, for example, was among the "Refusés" of 1863, but his great, light-filled painting *L'Espace* was finally admitted to the Luxembourg after the 1869 Salon. He opened up an amazingly wide vista over the countryside of Septeuil in the vicinity of Paris. The same huge scale engaged the attention of Guillaumet in *Le Désert*, but for a desolate, dramatic view of the Sahara using reddish tones, with a

v
Antoine Chintreuil
(1814-1873)
L'Espace
1869 Salon

Canvas
102 × 202
Purchased in 1869
R.F. 381

>
**Gustave Guillaumet
(1840-1887)**
Le Sahara or *Le Désert*
1867 Salon

Canvas, 110 × 200
Gift of the artist's family, 1888
R.F. 505

>>
**Charles-François
Daubigny
(1817-1878)**
La Neige
1873 Salon

Canvas, 90 × 120
Donation in lieu of payment
of death duty, 1989
R.F. 1989-30

>>
**Jean-Baptiste Carpeaux
(1827-1875)**
*L'Attentat de Berezowski
contre le tsar Nicolas II
(6 juin 1867)*

Canvas, 131 × 195
Purchased at the sale
of the artist's studio, 1906
R.F. 1598

v
**Eugène Fromentin
(1820-1876)**
*Chasse au faucon
en Algérie: la curée*
1863 Salon

Canvas, 162 × 118
Purchased in 1863
R.F. 87

contrast between the tiny caravan silhouetted on the horizon and the disturbing carcass of a camel in the foreground. In 1862 on his way to Rome Guillaumet had embarked at Marseilles for North Africa. He then developed a passion for Algeria, going there ten times.

The Italian model, so beloved by adherents of historical landscape, was abandoned in favour of direct observation of the widest variety of sites. The southern shores of the Mediterranean had become more accessible through colonisation, both in Algeria and Egypt, where the Suez Canal was officially opened by Empress Eugénie in 1869. Orientalist painting, sometimes anecdotal and sometimes naturalist in character, attracted a large number of buyers.

But there was no need to go so far to experiment with a new way of painting. During the winter of 1872-1873 at Auvers-sur-Oise Daubigny painted a large winter landscape, *La Neige*, which caused surprise at the 1873 Salon. Some conservative critics saw it as "a lump of plaster spread out with a palette knife" or trees painted with "a broom made of birch twigs". One year before the first exhibition by the Impressionist group, in this broadly painted canvas, boldly composed from contrasts between blacks and whites, we already sense the close links between Daubigny and the young artists of the new school of painting. This picture, one of Daubigny's masterpieces, can be compared with the famous *Champ de blé aux corbeaux* (Van Gogh Museum, Amsterdam) painted by Van Gogh in 1890 in the final weeks of his life near the same village of Auvers-sur-Oise.

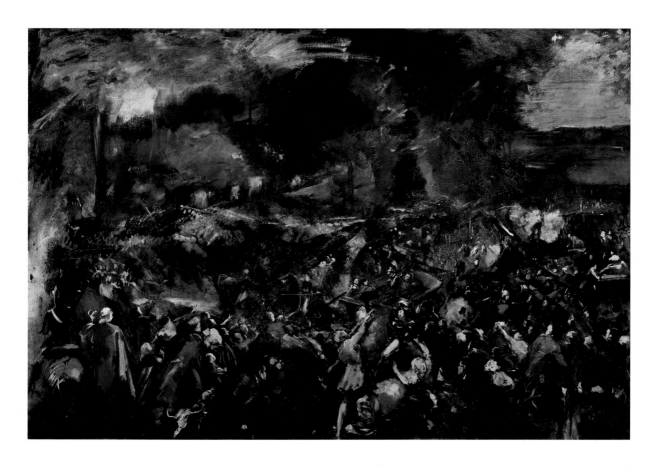

We are now receptive to this rough technique which can appropriately be likened to Courbet's and that of younger artists like Cézanne or Pissarro, who also spent time at Auvers-sur-Oise in that winter of 1872-1873.

The works of other artists using a broad, colourful technique but whose careers were played out in the provinces – Ravier, a friend of Daubigny, around Lyons; Monticelli, later admired by Van Gogh, and Guigou in Marseilles – were not bought for the Musée du Luxembourg, only entering the Louvre at a later date. The same is true of the rapidly executed paintings of Carpeaux, a successful sculptor, which remained unknown until 1906.

Portraiture was virtually excluded from the Luxembourg collections during the Second Empire. Even Carolus-Duran's *Dame au gant*, exhibited at the 1869 Salon, was only acquired in 1875 when the artist had already achieved recognition. Like James Tissot's *Jeune fille en veste rouge*, which was shown at the 1864 Salon and acquired by the museum in 1907, the *Dame au gant*, a portrait of the painter's wife, is one of those pivotal works in which the artist shows what he is capable of doing if requested.

^
^
Auguste Ravier
(1814-1895)
L'Étang de la Levaz
à Morestel (Isère)

Canvas
25 × 33.5
Gift of Félix Thiollier, 1909
R.F. 1749

^
Adolphe-Joseph
Monticelli
(1824-1886)
Don Quichotte et Sancho
Pança
c. 1865

Canvas
96.5 × 130
Purchased with the
accumulated interest on
an anonymous Canadian
donation, 1953
R.F. 1953-31

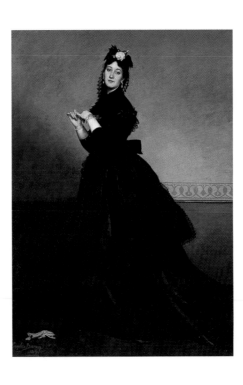

<
Carolus-Duran
(1838-1917)
La Dame au gant
1869 Salon

Canvas
228 × 164
Purchased in 1875
R.F. 152

>
James Tissot
(1836-1902)
Portrait de Mlle L. L.,
also known as *Jeune Fille*
en veste rouge
1864 Salon

Canvas
124 × 99.5
Purchased in 1907
R.F. 2698

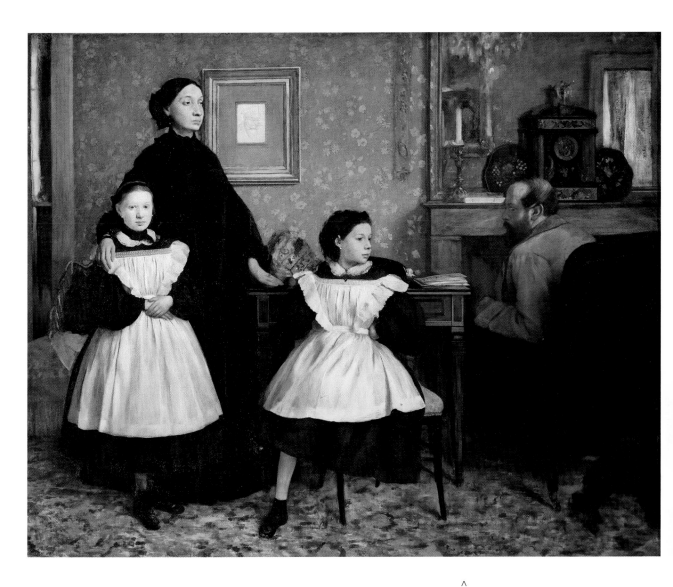

∧
Edgar Degas (1834-1917)
Portrait de famille. La Famille Bellelli
Started in 1858 - 1867 Salon

Canvas, 200 × 250
Purchased at the first sale of the artist's studio
with the assistance of Comte and Comtesse
de Fels and thanks to René Degas, 1918
R.F. 2210

It was only with the sale of Degas's estate in 1918 that one of his greatest paintings, *La Famille Bellelli*, was bought; he had started it in Florence in 1858, then exhibited it at the 1867 Salon under the anonymous title *Portrait de famille*. In fact, as the painter himself emphasised, it is more of a "picture" than a mere portrait of the disunited household of his Aunt Laure. He makes us aware of the family drama through an interplay of gazes that do not meet, while the younger of his two cousins, with one leg tucked up under her dress, suggests all the unruliness of her age. The portrait in red chalk of his grandfather who had died a short time before is shown on the drawing-room wall, explaining the black dresses the two girls are wearing under their white pinafores.

<
**Édouard Manet
(1832-1883)**
*Monsieur et Madame
Auguste Manet,*
the artist's parents
1860
1861 Salon

Canvas
110 × 90
Purchased thanks to the Rouart-
Manet family, Mme Veil-Picard
and a foreign donor, 1977
R.F. 1977-12

>
**James McNeill Whistler
(1834-1903)**
Variations in Violet and Green
1871

Canvas
61 × 35.5
Purchased with the help of the Fonds
du Patrimoine and thanks to the
generosity of M. Philippe Meyer,
1995
R.F. 1995-5

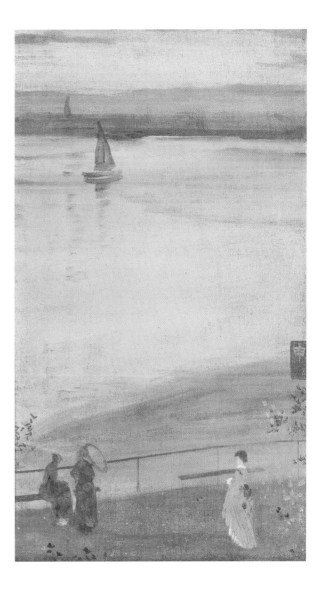

There is nothing surprising about the fact that the stars
of the Salon des Refusés of 1863 (Manet, Fantin-Latour
and Whistler, an American who divided his time between
London and Paris) did not gain admittance to the
Luxembourg until about 1890. Indeed, Whistler let the
museum have *Arrangement in Grey and Black: Portrait of
the Artist's Mother* for a token sum, for which the glory of
admission to the Luxembourg was probably ample
compensation; he had painted it in London in 1871 and
sent it to the Paris Salon in 1883. While the artist was
admittedly represented by his masterpiece, the collections
did not include a landscape to demonstrate the diversity
of his talent. *Variations in Violet and Green*, purchased in
1995, painted rapidly in London in August 1871 after a

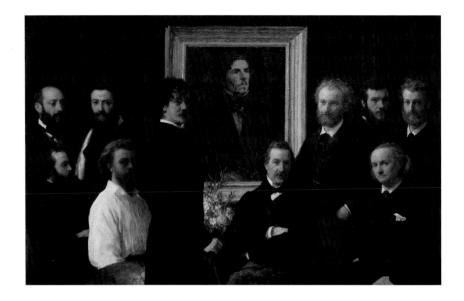

<Henri Fantin-Latour
(1836-1904)
Hommage à Delacroix
1864 Salon

Canvas
160 × 250
Étienne Moreau-Nélaton
donation, 1906
R.F. 1664

v
**Henri Fantin-Latour
(1836-1904)**
Fleurs et fruits
1865

Canvas
64 × 57
Assigned by the Office des
Biens Privés, 1950
M.N.R. 227

boat trip on the Thames, is one of the allusive landscapes that heralded Claude Monet's *Impression, Soleil levant*.

In his group portraits Fantin-Latour, who had depicted Whistler alongside Manet, Baudelaire and Champfleury in *Hommage à Delacroix* at the 1864 Salon, had the knack of setting down the likenesses of the most innovative painters or poets. The famous picture of the very young Arthur Rimbaud in the company of Paul Verlaine shown at the 1872 Salon in *Un coin de table* is his work. Under this descriptive title, which tends to draw attention to the brilliant still life suggesting the end of a meal, Fantin-Latour depicts the *Vilains Bonhommes* (nasty fellows), a group of Parnassian poets who met for dinner once a month at the Palais Royal from the last days of the Second Empire onwards. Once peace had been restored they decided to found an avant-garde literary review, *La Renaissance littéraire et artistique*. Its first issue is dated 27 April 1872, at the time of the Salon. Fantin-Latour, who after a visit to his studio Edmond de Goncourt cattily described as "the awarder of fame to public house geniuses", spent a long time preparing this picture. It was initially conceived as a tribute to Baudelaire, who had died in 1867, to be shown at the 1871 Salon, which was not held because of the Franco-Prussian War and the Commune.

He abandoned the original symmetry and inserted his models life-size; they were summoned to his studio to sit for him – all the portraits are remarkable likenesses – with

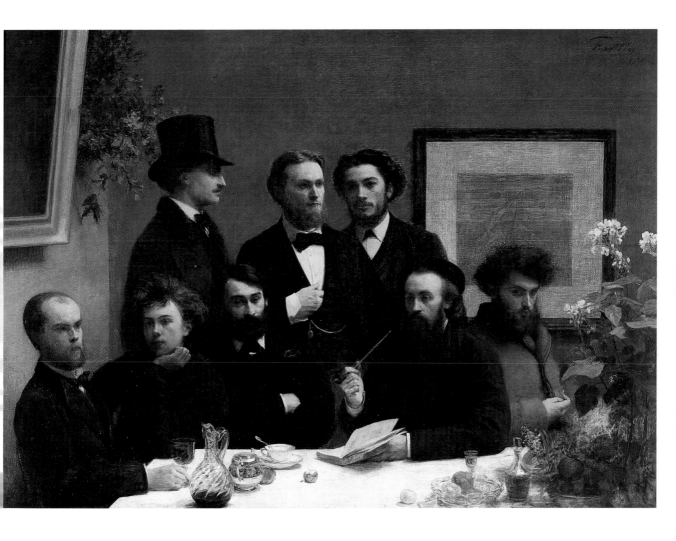

∧
**Henri Fantin-Latour
(1836-1904)**
Coin de table
1872 Salon

Canvas
160 × 225
Donation from M. and
Mme L. E. Petitdidier, known
as E. Blémont, with reservation
of lifetime use, 1910; lifetime
use renounced, 1920
R.F. 1959

the idea of rivalling the Dutch guild portraits of the 17th century. He recorded the protagonists of the literary vanguard of his day for all time. Although one of the poets who proved stubborn has been replaced by the bunch of flowers on the right, the artist skilfully plays on the contrast between the black clothes of the day – which Baudelaire himself had recommended portraying – and the dazzling whiteness of the tablecloth. He was tackling the same problem as Courbet twenty years earlier: raising representations of modern life from the status of genre scenes to that of history paintings. There can be no doubt that he has succeeded.

Thus the strong personalities of the day who were ill-treated by the official system and totally ignored by the Musée du Luxembourg were already united as a group, bound by ties of friendship and aesthetic affinities.

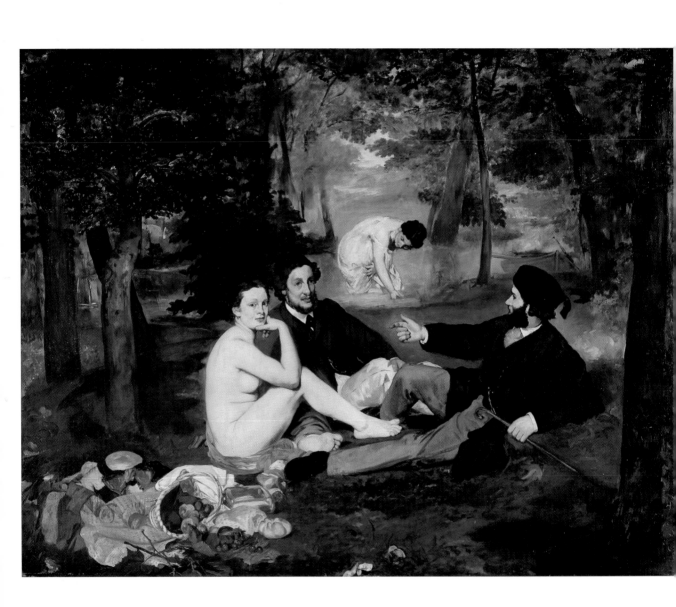

Impressionism

The Impressionist movement got its name from derisive comments about a picture by Monet shown at the first exhibition by the group in 1874: *Impression, Soleil levant,* today in the Musée Marmottan in Paris. Punctuated by scandals, the story of Impressionism is that of a revolution in painting from which there was no going back.

<
Édouard Manet
(1832-1883)
Le Déjeuner sur l'herbe
Salon des Refusés, 1863

Canvas
208 × 264
Étienne Moreau-Nélaton donation, 1906
R.F. 1668

∨
Pierre-Auguste Renoir
(1841-1919)
Frédéric Bazille à son chevalet - 1867
Second Impressionist Exhibition, 1876

Canvas
105 × 73.5
Bequest of Marc Bazille, the model's brother, 1924
R.F. 2448

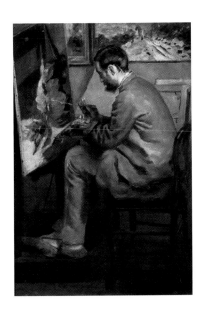

Fantin-Latour was an habitué of the Café Guerbois, which was the scene of many a violent discussion between the future Impressionists and their critics. His huge 1870 canvas *L'Atelier des Batignolles* shows the avant-garde of French painting, Renoir, Bazille and Monet, gathered in the café around Manet. All three had studied in the highly academic Gleyre studio; nonetheless, they were passionate emulators of the man who painted *Le Déjeuner sur l'herbe.* With them, Fantin-Latour depicted their supporters, Edmond Maître, Zacharie Astruc and Zola, critics who had taken a brave public stand in preferring their work to that of the stars of the contemporary Salon. With its fine classical treatment, which doubtless smoothed the way for its acquisition by the Musée du Luxembourg in 1892, this great painting serves as a counterpoint to the *Hommage à Delacroix* of a few years earlier, in showing the state of the painting avant-garde just before the upheavals of the war of 1870 and the Commune. Manet, the uncontested leader, was "a man of great modesty and gentleness", in Zola's phrase; but he was also highly energetic and ambitious, and this, coupled with the daring of his art, explains the influence he wielded over painters like Monet, Renoir and Bazille, who were not very much younger than he.

The same group appears in a much more relaxed canvas by Bazille dating from the same time, depicting the latter's atelier in the Rue de la Condamine. Bazille, a native of Montpellier from a well-to-do background, had arrived in Paris in 1862 as a young man and immediately made friends with Monet and Renoir. All the same, the principles used in this free evocation of Bazille's studio are those of Manet; on the walls are Bazille's most recent

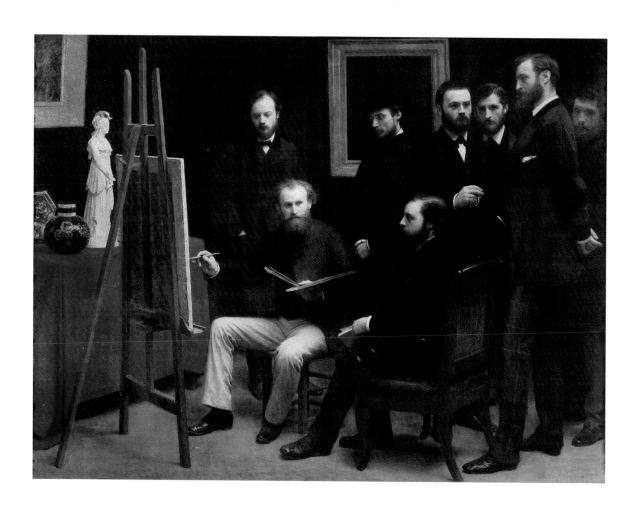

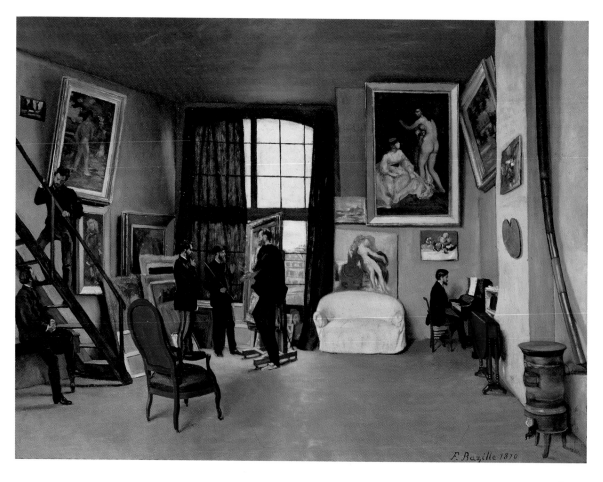

F. Bazille 1870

canvases, among them his *Nude* in the process of being painted. This picture, entitled *La Toilette,* was refused admittance to the 1870 Salon; this was the occasion of Bazille's last public appearance, since he volunteered shortly afterward for the army and was tragically killed in battle at Beaune-la-Rollande the same year. In 1870, Bazille's painting was typical of the ambiguous and uncomfortable position of many another future Impressionist; their style of painting was acceptable but they were repeatedly refused entry to the Salon. Hence they were not yet ready to give up trying, and sometimes they succeeded in persuading the jury to admit them.

This was not Manet's case in 1863. The historic rejection of his *Déjeuner sur l'herbe* by the Salon of that year (along with innumerable works by other artists such as Whistler, Cazin and Pissarro) caused a general outcry in the painting establishment. Recognizing this, Emperor Napoleon III authorized the "Refusés" to exhibit their paintings under Manet's banner in rooms adjacent to the Salon: hence the name Salon des Refusés. *Le Déjeuner sur l'herbe* was the star of this alternative Salon and attracted a hail of sarcasm from the public and critics. In the real Salon, the Venuses of Cabanel, Baudry and Amaury-Duval were extravagantly praised, and the emperor himself purchased Cabanel's picture for the Luxembourg. Manet's *Déjeuner sur l'herbe* remained for twenty years in his studio, before being bought by the singer Faure, then the great dealer Durand-Ruel. It finally came into the hands of Moreau-Nélaton just before 1900, and it is to this brilliant collector that we owe the entry of Manet's masterpiece to the Louvre in 1907. In the same year *Olympia,* which had been offered to the state in 1890, produced another armed rising when the decision was made to hang it in the Louvre beside Ingres' *La Grande Odalisque.*

Both *Le Déjeuner sur l'herbe* and *Olympia* are based on classical art. Titian's *Concert champêtre* (Louvre) and an engraving from the school of Raphael were the sources for the *Déjeuner,* while Titian's *Venus of Urbino* (Florence, Uffizi) and Goya's *Maja desnuda* (Madrid, Prado) inspired *Olympia.* Manet's apparent lack of deference to his predecessors and his resolutely modern interpretation profoundly shocked the public. Rare indeed were the critics like Zola and Astruc, who were capable of recog-

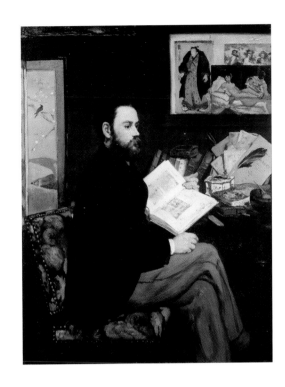

∧
**Édouard Manet
(1832-1883)**
Émile Zola (1840-1902)
1867-1868
1868 Salon

Canvas
146.5 × 114
Donation from Mme Zola with
reservation of lifetime use, 1918;
entered collection in 1925
R.F. 2205

<
**Henri Fantin-Latour
(1836-1904)**
Un atelier aux Batignolles
1870 Salon

Canvas
204 × 273
Purchased in 1892
R.F. 729

<
**Frédéric Bazille
(1841-1870)**
*L'Atelier de Bazille, 9, rue
de la Condamine, à Paris*
1870

Canvas
98 × 128
Bequest of Marc Bazille,
the artist's brother, 1924
R.F. 2449

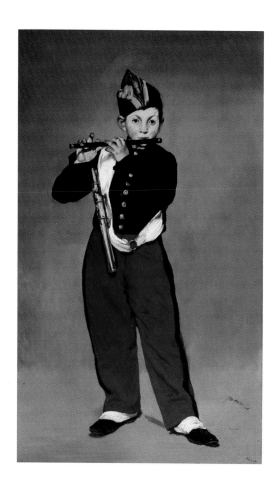

∧
**Édouard Manet
(1832-1883)**
Le Fifre
1866

Canvas
161 × 97
Bequest of Comte Isaac
de Camondo, 1911
R.F. 1992

>
**Édouard Manet
(1832-1883)**
*Berthe Morisot au bouquet
de violettes*
1872

Canvas
55.5 × 40.5
Purchased with the
participation of the Fonds
du Patrimoine, the Meyer
foundation, the *China Times*
group and patronage
coordinated by the *Nikkei*
newspaper, 1998
R.F. 1998-30

nizing Manet's genius for fresh treatment of traditional subjects and daring method of painting *par taches* (in patches). "Manet! One of the greatest artistic characters of our time", wrote Astruc in 1863.

As for Zola, after a spirited defence of both paintings, he went on to write an article that aroused worldwide interest in 1867, entitled "A new way of painting: Edouard Manet". Pretending to address the painter, he wrote: "Tell them, *cher maître...* that for you a painting is merely a pretext for analysis. You needed a naked woman, and Olympia was the first to mind; you needed clear, luminous patches, so you painted a bunch of flowers; you needed something black, so you put a negress and a cat in one corner. What does it all mean? You scarcely know, and neither do I. But I do know that you have done the work of a painter, even a great painter; by which I mean that in your own special language you have vigorously interpreted the truths of light and shadow and the realities of objects and living creatures."

The following year, the painter paid Zola the tribute of painting his portrait, with *Olympia* in the background beside a Japanese print, a testament to the growing fascination of contemporary artists with the art of Japan.

The Manet collection at the Musée d'Orsay, which is mostly composed of the gifts and bequests of Caillebotte, Moreau-Nélaton and Camondo, is indicative of the highs and lows of the painter's career. He continued calmly to submit his work to the test of the Salon, unmoved by historic rebuffs like that of *Le Déjeuner sur l'herbe* or *Le Fifre,* or even by triumphs like that of *Le Balcon,* a portrait of his friend Berthe Morisot which was admitted in 1869.

Morisot, an appealing female figure in the Impressionist movement, became Manet's sister-in-law when she married his brother in 1874. Elegant and endearing, she became his favourite model, and he made about twenty portraits of her. The sensational 1998 purchase of the portrait *Berthe Morisot au bouquet de violettes,* painted in 1872 and part of the Rouart Collection, was a major event in the preservation of the country's heritage, requiring help from the Fonds du Patrimoine, the Meyer Foundation, the China Times Group and an appeal for patronage coordinated by the *Nikkei* newspaper.

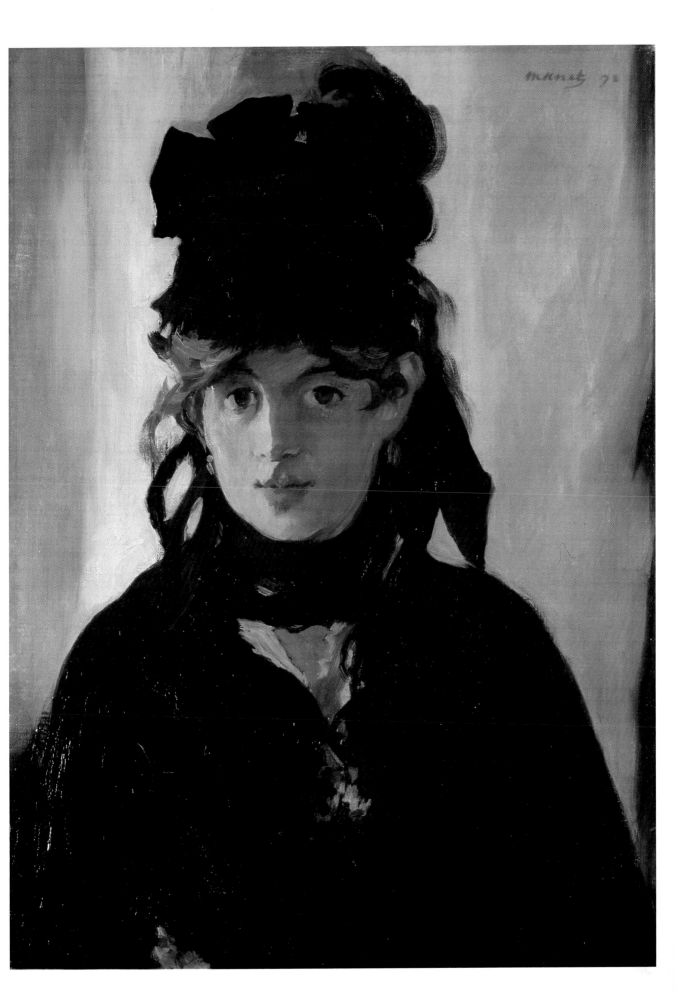

His development is clearly perceptible from the bluntly realist style of *Les Parents de l'artiste* (acquired in 1977) to later works stamped by the influence of the Impressionist techniques that he himself had helped to create *(Sur la plage, La Blonde aux Seins Nus)*.

Berthe Morisot's style was essentially derived from that of Manet, with subtleties of texture which were perfectly matched to the subjects she handled. With characteristic courage, this young woman from the *haute bourgeoisie* participated in all the Impressionist events (in 1874 she unveiled *Le Berceau,* a portrait of her sister Edma) except for the 1879 exhibition. Oddly enough, 1879 was the year that another woman took part for the first time: Mary Cassatt, from Pittsburgh, USA, had come to live in France not long before, and had found a mentor in Degas. The principal subjects of her paintings are women and children.

Bazille and Monet worked together constantly during the 1860s, and while their work expresses their different temperaments, it has undeniable similarities. The year he painted his own *Réunion de famille,* Bazille bought *Femme au jardin* from his friend Monet who had been rejected by the official Salon and could find no buyer for the painting. After Bazille's premature death, his father discovered that Manet possessed a portrait of Bazille by Renoir (now in the Musée d'Orsay) and offered to exchange it for *Femme au jardin.* Then, after a quarrel, Manet returned the painting

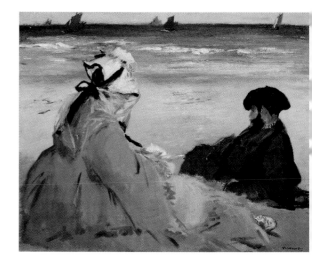

∧
**Édouard Manet
(1832-1883)**
Sur la plage
1873

Canvas
59.5 × 73
Donation from Jean-Édouard
Dubrujeaud with reservation
of lifetime use, 1953; entered
collection in 1970
R.F. 1953-24

>
**Claude Monet
(1840-1926)**
Déjeuner sur l'herbe
1865-1866

Canvas
248 × 217
Donation in lieu of payment of
death duty, 1987
R.F. 1987-12

<
**Frédéric Bazille
(1841-1870)**
Réunion de famille
1867
1868 Salon

Canvas
152 × 230
Purchased with the
participation of Marc Bazille,
the artist's brother, 1905
R.F. 2749

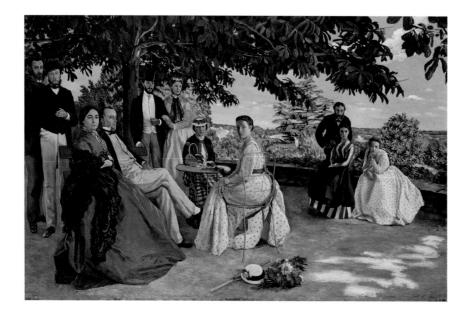

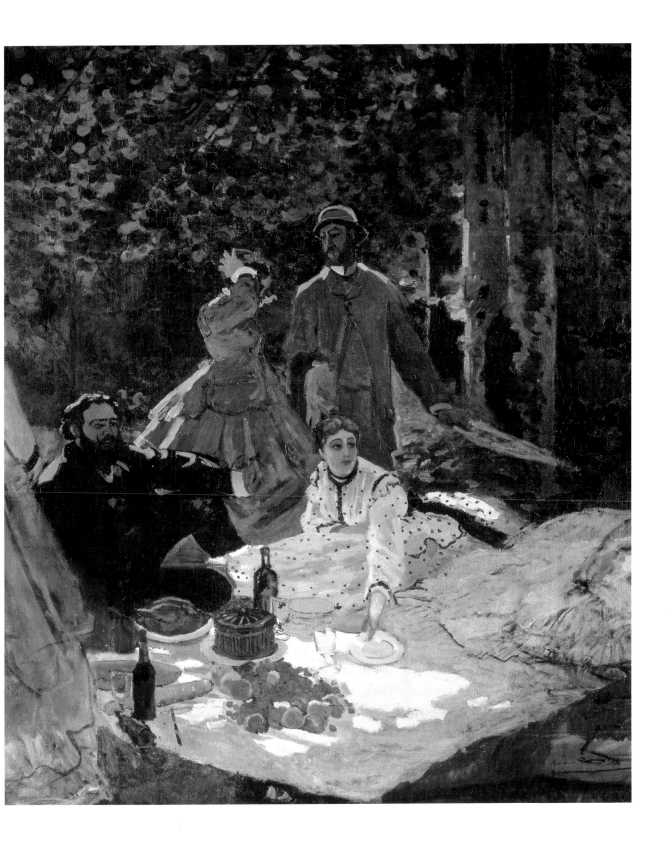

to Monet, who ultimately had the satisfaction of selling it to the Musées Nationaux in 1921 for a very high price.

In his ambitious painting *Déjeuner sur l'herbe,* started in May 1865 and left incomplete, the young 23-year-old Monet wanted to rival the great historical compositions by treating on a monumental scale a scene drawn from contemporary life. Of the initial composition – evident in

<Claude Monet
(1840-1926)
Femmes au jardin
1866-1867

Canvas
255 × 205
Purchased in 1921
R.F. 2773

>
Claude Monet
(1840-1926)
*Hôtel des Roches Noires.
Trouville*
1870

Canvas
81 × 58.5
Jacques Laroche donation
with reservation of lifetime
use, 1947; entered collection
in 1976
R.F. 1947-30

a sketch in the Pushkin Museum in Moscow – all that remains is the left part and, in particular, the central section which Monet kept in his studio until his death. These are now reunited at the Musée d'Orsay.

Monet's *Déjeuner sur l'herbe* was a direct response to Manet. This painting was quickly followed by *Femmes au jardin,* another large canvas with Camille Doncieux, who was to become Monet's wife in 1870, among its figures. According to a friend of Monet, *Femmes au jardin* was "begun in the open air and painted from life", quite an accomplishment in view of its size. The work was refused admittance to the 1867 Salon, and although to some extent it reflects Manet's influence, its main interest is in the light it casts on the experiments of Monet himself: namely, the preservation, in the completed work, of the vivacity inherent in the sketch, the blending of figures into surrounding space by an energetic interplay of shadow and light, and the whole composition painted with broad juxtaposed strokes.

∧

**Alfred Sisley
(1839-1899)**
Passerelle d'Argenteuil
1872

Canvas
39 × 60
Étienne-Moreau-Nélaton
donation, 1906
R.F. 1688

<

**Claude Monet
(1840-1926)**
Régates à Argenteuil
c. 1872

Canvas
48 × 75
Gustave Caillebotte
bequest, 1894
R.F. 2778

<

**Claude Monet
(1840-1926)**
La Pie, Étretat
1868-1869

Canvas
89 × 130
Purchased in 1984
R.F. 1984-164

Thematic and open air painting were at the heart of the Impressionist initiative, from the first experiments of Monet and Boudin to the work of Courbet on the Normandy coast. The open air was crucial to their doctrine, and became a principle of composition intimately linked to the development of a pictorial technique which sought to render the spontaneity of the perceived impression by way of the subject's variations according to light. In this context, the technique generated a style and then a whole philosophy of the act of painting; this Monet was to push to its outer limits with his famous sequence of paintings, represented at the Musée d'Orsay by *Les Meules,* the five *Cathédrales de Rouen* and *Nymphéas bleus.* In this regard, the Impressionist collection offers a particularly striking demonstration of the implications of open air painting, since it is mainly composed of landscapes of the great Impressionist shrines of the Normandy coast *(L'Hôtel des Roches Noires),* Argenteuil *(Régates),* Pontoise *(Les Toits rouges),* Auvers-sur-Oise, Vétheuil, Eragny and Giverny. The acquisition of *La Pie* in 1985 added a masterpiece to an already impressive series. Monet probably painted this in January or February 1869 during a stay in the Etretat region, and its stunning variations of white show the painter's extraordinary scrutiny of light effects and above all his great technical mastery.

∧

Claude Monet
(1840-1926)
Coquelicots; near Argenteuil
1873
First Impressionist
Exhibition, 1874

Canvas
50 × 65
Étienne Moreau-Nélaton
donation, 1906
R.F. 1676

After the 1870 war, which had dispersed them widely, the group gathered once again around Monet, who went to live at Argenteuil on the banks of the Seine around 1871. Here Monet, Renoir, Sisley and later Manet came to paint the same subjects, immortalising in a series of wonderfully fresh canvases the regattas at Argenteuil and the marina with its two bridges. This golden age of Impressionism is abundantly represented at the Musée d'Orsay by paintings from the Caillebotte bequest, the Moreau-Nélaton gift and the Personnaz and Camondo bequests. Monet's famous *Coquelicots* was also painted at Argenteuil; this picture figured in the first Impressionist exhibition of 1874, and was echoed by Renoir's *Chemin montant dans les hautes herbes.*

<
**Pierre-Auguste Renoir
(1841-1919)**
*Chemin montant dans
les hautes herbes*
c. 1875

Canvas
60 × 74
Gift of Charles Comiot through
the Association of Friends of the
Louvre, 1926
R.F. 2581

v
**Camille Pissarro
(1830-1903)**
Portrait de l'artiste
1873

Canvas
56 × 46.7
Donation from Paul-Émile
Pissarro, the artist's son,
with reservation of lifetime
use, 1930; entered collection
in 1947
R.F. 2837

Escaping from Paris's excessively high rents and always keen to find new motifs, Monet before long turned Argenteuil into the true centre of Impressionism. With his friends he painted the banks of the Seine, then covered with greenery, or the sailing-boat regattas, his other favourite subject. This period between 1872 and 1874 marked the time of the movement's greatest unity and fullest development.

Pissarro and Cézanne first met in 1861. When Cézanne moved to Auvers-sur-Oise, in 1872, he found himself in close proximity to his friend at Pontoise. Although at that time Pissarro seemed to exercise a preponderant influence on Cézanne, notably by encouraging him to lighten his range of colours, there is no doubt that the latter had a reciprocal effect on Pissarro's work. Pissarro contributed to the first Impressionist exhibition in 1874 (*Gelée blanche* was shown on this occasion, provoking much irony and incomprehension), and invited Cézanne

<
**Camille Pissarro
(1830-1903)**
Gelée blanche
1873
First Impressionist
Exhibition, 1874

Canvas
65 × 93
Enriqueta Alsop bequest
in the name of Dr Eduardo
Mollard, 1972
R.F. 1972-27

<
**Paul Cézanne
(1839-1906)**
*La Maison du pendu,
Auvers-sur-Oise*
1873

Canvas
55 × 66
Bequest of Comte Isaac
de Camondo, 1911
R.F. 1970

∧

**Camille Pissarro
(1830-1903)**
*Les Toits rouges, coin
de village, effet d'hiver*
1877

Canvas
54.5 × 65.6
Gustave Caillebotte
bequest, 1894
R.F. 2735

to participate; this led to the first appearance of *La Maison du pendu,* a scene painted near Auvers-sur-Oise.

Having produced heavily-structured landscapes of the Pontoise region such as *Le Coteau de l'Hermitage, Pontoise* (which recently entered the Orsay collection as a donation in lieu of payment of death duty), Pissarro adopted a more fluid manner with his famous *Gelée blanche* and *Les Toits rouges,* both featured in the Impressionist exhibitions of 1874 and 1877. The museum also possesses a fine self-portrait by this artist, and he is otherwise well represented by forty or so paintings from every stage of his long career, chiefly thanks to the Personnaz bequest of 1937. Fourteen canvases painted at Louveciennes, Pontoise and finally Eragny, where the artist settled in 1884, show the development of his technique from its beginnings right up to the pointillist phase between 1886-1888 and beyond. *La Vue du pont de Rouen* also shows that Pissarro could be an excellent painter of town scenes, and that he was

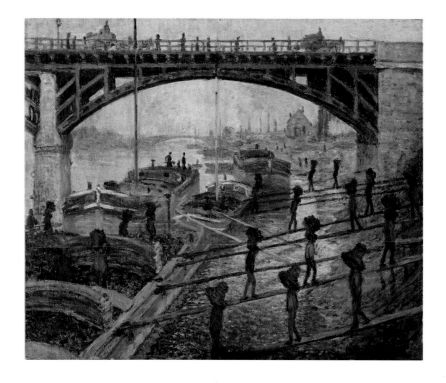

<
**Claude Monet
(1840-1926)**
*Les Déchargeurs de
charbon*
c. 1875
Fourth Impressionist
Exhibition, 1879

Canvas
55 × 66
R.F. 1993-21

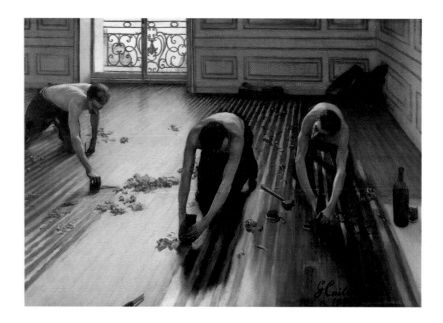

<
**Gustave Caillebotte
(1848-1894)**
Raboteurs de parquet
1875
Second Impressionist
Exhibition, 1875

Canvas
102 × 146.5
Gift of Gustave Caillebotte's
heirs through the aegis of
Auguste Renoir, 1894
R.F. 2718

acutely aware of the environmental changes that were taking place under the pressure of industrial development.

This same aspect, very unusual in the work of Monet, is shown in the picture that entered the museum through a donation in lieu of payment of death duty in 1995: *Les Déchargeurs de charbon* painted in 1875. It appeared in the fourth Impressionist exhibition in 1879 under the title *Les Charbonniers*, and was bought by Monet's dealer

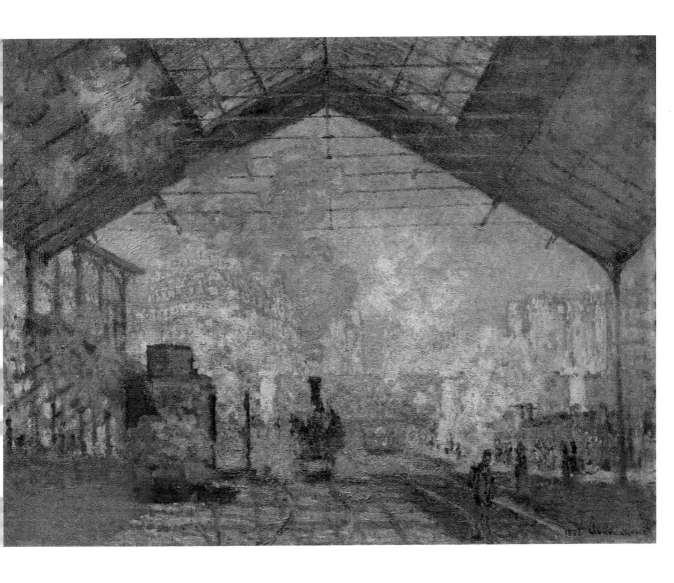

**Claude Monet
(1840-1926)**
La Gare Saint-Lazare
Third Impressionist
Exhibition, 1877

Canvas
75 × 104
Gustave Caillebotte
bequest, 1894
R.F. 2775

Durand-Ruel. The Seine, which Monet usually depicted as a popular place of leisure for Parisians, here appears as a new focus of economic development, according to a powerful geometric building framed by the Pont d'Asniéres and the Pont de Clichy which can be discerned in the background.

For Monet and his colleagues, Paris in the aftermath of Haussmann's changes offered a fresh new artistic theme. It was not so much the buildings that interested Monet as the seething life of the boulevards, the foliage of the parks, and the intense colours of the flags put out on holidays; these he rendered in sensitive, delicate brushwork, in compositions that were allusive to the point of abstraction. Another modern subject, the Gare Saint-Lazare, reveals Monet's taste for repetition of the same theme in various lights: two versions of this theme have come down to us.

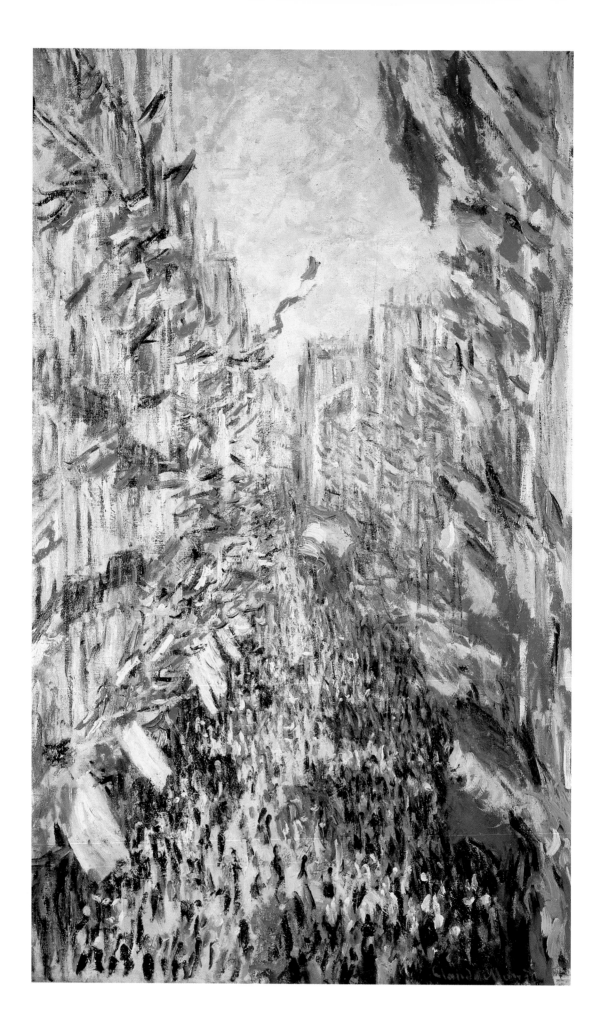

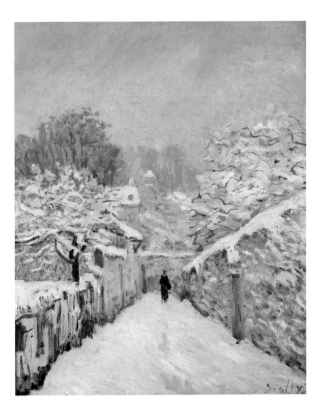

>
Alfred Sisley
(1839-1899)
La Neige à Louveciennes
1878

Canvas
61 × 50.5
Bequest of Comte Isaac
de Camondo, 1911
R.F. 2022

While Pissarro played a prominent role as mainspring of the eight Impressionist exhibitions between 1874 and 1886, the figure of Sisley was more discreet. Success eluded Sisley all his life, and constant material difficulties forced him to live almost permanently in the country, far from Paris. Over thirty-five of his paintings at the Musée d'Orsay, dominated by the two masterpieces of *L'Inondation à Pont-Marly* from the Camondo bequest, show all the sites that this artist loved: Bougival, Louveciennes, Marly-le-Roi, Saint-Mammes and Moret-sur-Loing.

<
Claude Monet
(1840-1926)
La Rue Montorgueil, à
Paris. Fête du 30 juin 1878
1878
Fourth Impressionist
Exhibition, 1879

Canvas
81 × 50.5
Donation in lieu of payment
of death duty, 1982
R.F. 1982-71

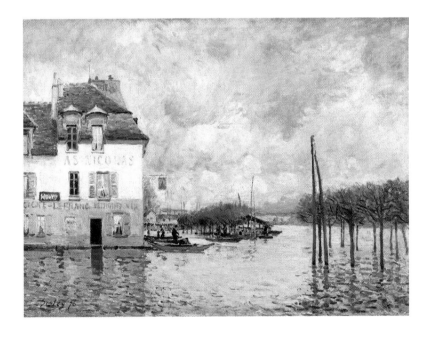

>
Alfred Sisley
(1839-1899)
L'Inondation à Port-Marly
1876
Second Impressionist
Exhibition, 1876

Canvas
60 × 81
Bequest of Comte Isaac
de Camondo, 1911
R.F. 2020

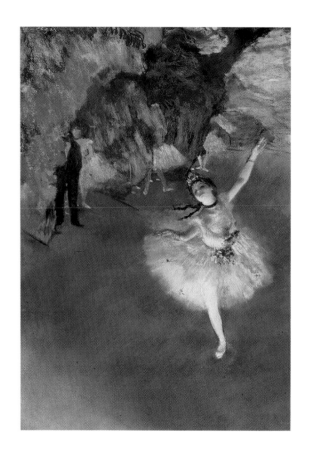

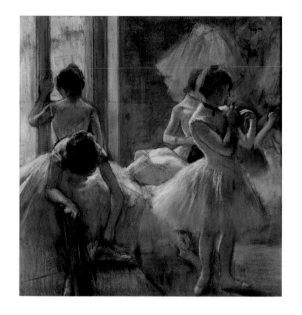

∧
**Edgar Degas
(1834-1917)**
L'Étoile
c. 1876-1877

Pastel on monotype
60 × 44
Gustave Caillebotte
bequest, 1894
RF 12258

∧ ∧
**Edgar Degas
(1834-1917)**
Danseuses
c. 1884-1885

Pastel
75 × 73
Donation in lieu of payment
of death duty, 1997
RF 51757

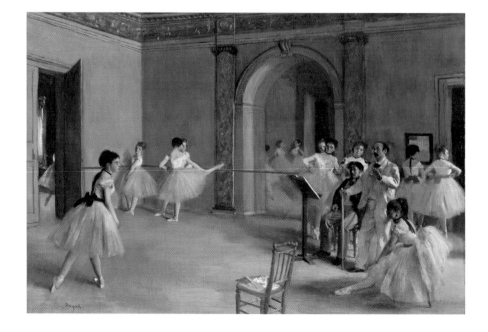

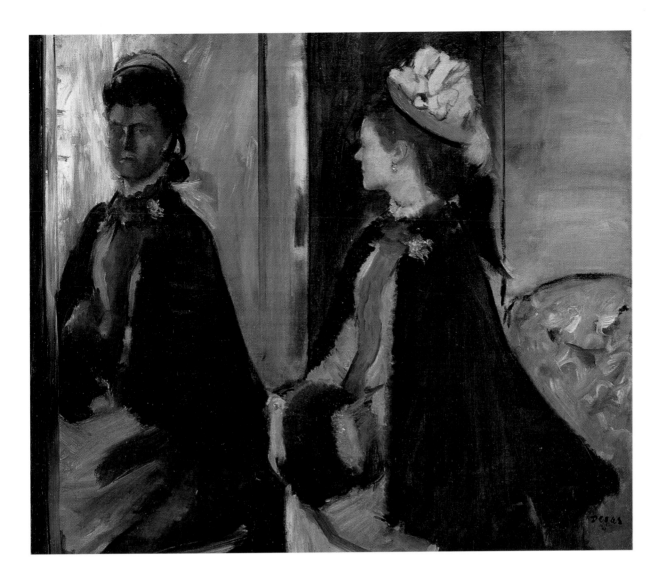

∧
Edgar Degas
(1834-1917)
Madame Jeantaud au miroir
c. 1875

Canvas
70 × 84
Bequest of Jean-Édouard Dubrujeaud with
reservation of lifetime use on behalf of his
son Jean Angladon-Dubrujeaud, 1970;
lifetime use renounced, 1970
R.F. 1970-38

<
Edgar Degas
(1834-1917)
Le Foyer de la danse à
l'Opéra de la rue Le Peletier
1872

Canvas
32 × 46
Bequest of Comte Isaac
de Camondo, 1911
R.F. 1977

Although less attracted than his colleagues by landscapes and the open air, Degas was an assiduous habitué of racecourses and a passionate interest in horses is reflected in both his painting and his sculpture. By virtue of the Caillebotte donation (*L'Étoile,* plus several matching pastels), the Musée d'Orsay possesses an exceptional Degas collection. The world of the opera, a major pole of attraction for this painter, is also copiously represented by his series of orchestra musicians, dance classes, ballet rehearsals and many pastels of dancers at work. In addition, there is an impressive gallery of Degas portraits (*Madame Jeantaud,* among others); the masterpiece *L'Absinthe,* which figured in the third Impressionist exhibition; and a consecutive series of pastels of women at their toilette *(Le Tub).* All of these pastels show the inexhaustible technical inventiveness of Degas in observing "the human animal attending to its needs".

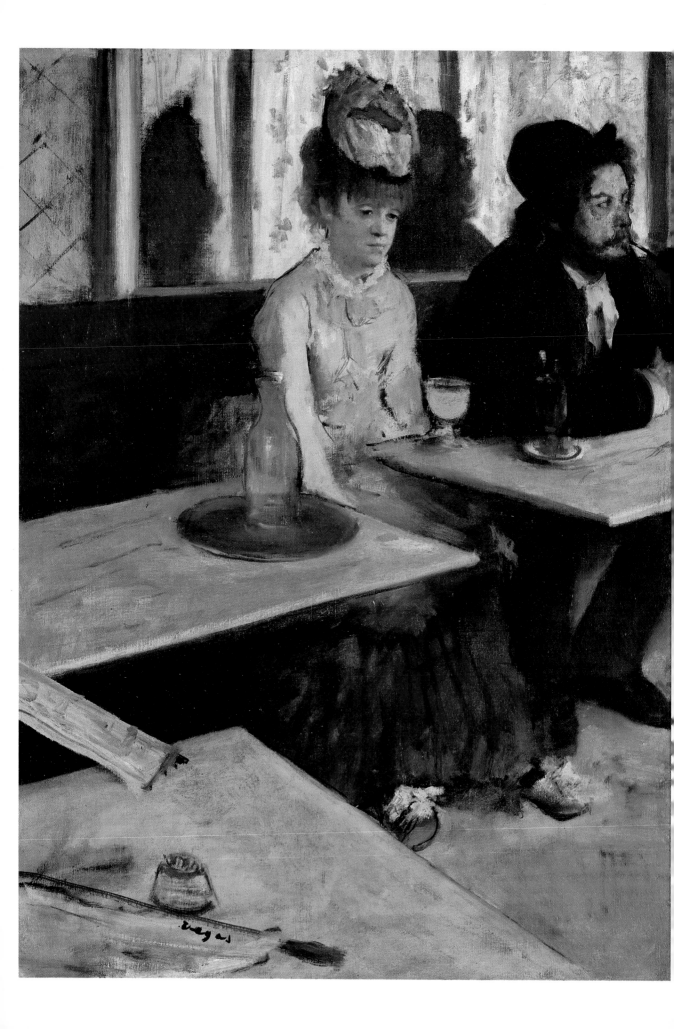

<
**Edgar Degas
(1834-1917)**
Au café, also
known as *L'Absinthe*
c. 1875-1876

Canvas
92 × 68
Bequest of Comte Isaac
de Camondo, 1911
R.F. 1984

>
**Edgar Degas
(1834-1917)**
Repasseuses
1884-1886

Canvas
76 × 81.5
Bequest of Comte Isaac
de Camondo, 1911
R.F. 1985

∨
**Edgar Degas
(1834-1917)**
Le Tub
1886

Pastel on cardboard
60 × 83
Bequest of Comte Isaac
de Camondo, 1911
R.F. 4046

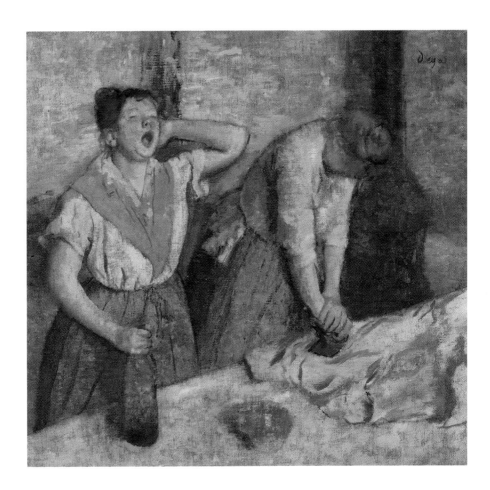

Degas once proclaimed: "No art is as unspontaneous as mine. What I do is the result of contemplation and the study of the old masters." This may be surprising, given that most of Degas' paintings seem to express an immediate ephemeral reality. His attention to human nature and enthusiasm for detail shine through in nearly every case. Moreover, Degas' care and sensitivity for line has the effect of defining clear forms within subtly constructed or suggested spaces – see the play of reflections in *Madame Jeantaud* or the apparently suspended composition of the tables in *L'Absinthe.*

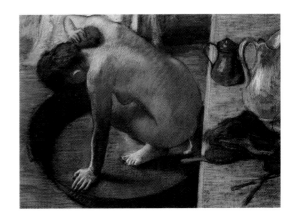

>
**Berthe Morisot
(1841-1895)**
Le Berceau
1872
First Impressionist
Exhibition, 1874

Canvas
56 × 46
Purchased in 1930
R.F. 2849

>
**Mary Cassatt
(1844-1926)**
Woman Sewing
c. 1880-1882
Eighth Impressionist
Exhibition, 1886

Canvas
92 × 63
Antonin Personnaz
bequest, 1937
R.F. 1937-20

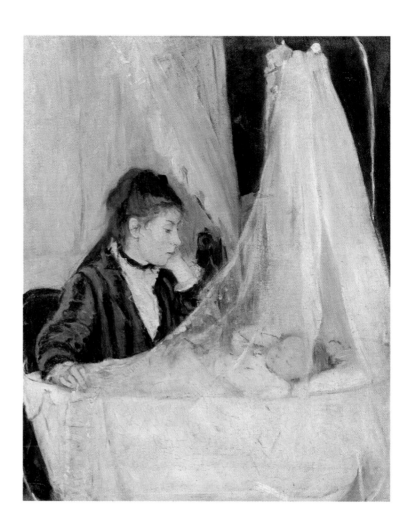

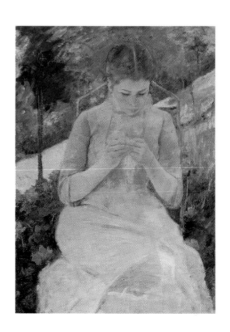

The American painter Mary Cassatt conceived a fervent admiration for Degas as soon as she saw his work at the 1874 Salon. However, she waited until 1879 before joining an Impressionist exhibition, and subsequently participated in the shows of 1880, 1881, and 1886, when she presented her charming *Woman sewing*. Among the other women Impressionists at the Musée d'Orsay, Berthe Morisot is best represented with her *Berceau* and the delicate *Chasse aux papillons,* whilst a single canvas testifies to the work of Eva Gonzalès, a pupil of Manet.

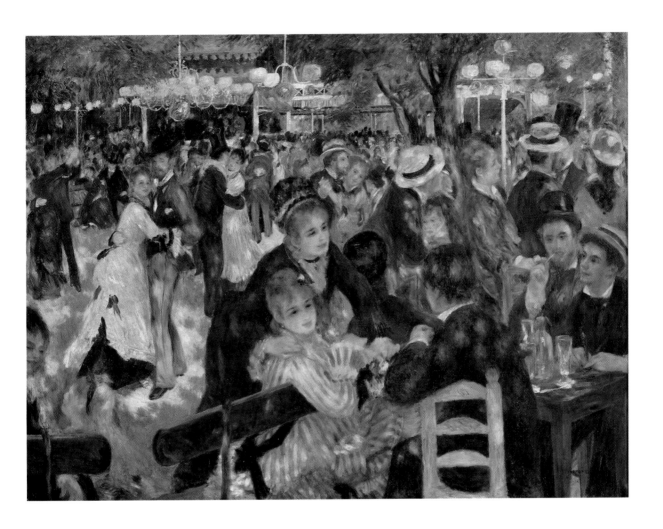

∧
**Pierre-Auguste Renoir
(1841-1919)**
*Bal du Moulin de la
Galette, Montmartre*
1876
Third Impressionist
Exhibition, 1877

Canvas
131 × 175
Gustave Caillebotte
bequest, 1894
R.F. 2739

From 1896 onwards, the national collections were remarkably enriched with works by Renoir, thanks to the Caillebotte bequest which included *Le Moulin de la galette, La Balançoire* and *La Liseuse*. Today, these three paintings are among the Musée d'Orsay's greatest treasures. With more than fifty canvases, the Orsay collection gives an idea of the sheer fecundity of an artist who, like Monet, lived to a great age. The many portraits – of Bazille, Monet, Mme Alphonse Daudet, Mme Georges Charpentier, Wagner and Gabrielle, the painter's servant girl – prove Renoir's constant interest in the human face. Three paintings done in Algeria in 1881 show a new direction in the artist's style, following the frankly Impressionist *Chemin dans les hautes herbes* and *Pont de chemin de fer à Chatou.*

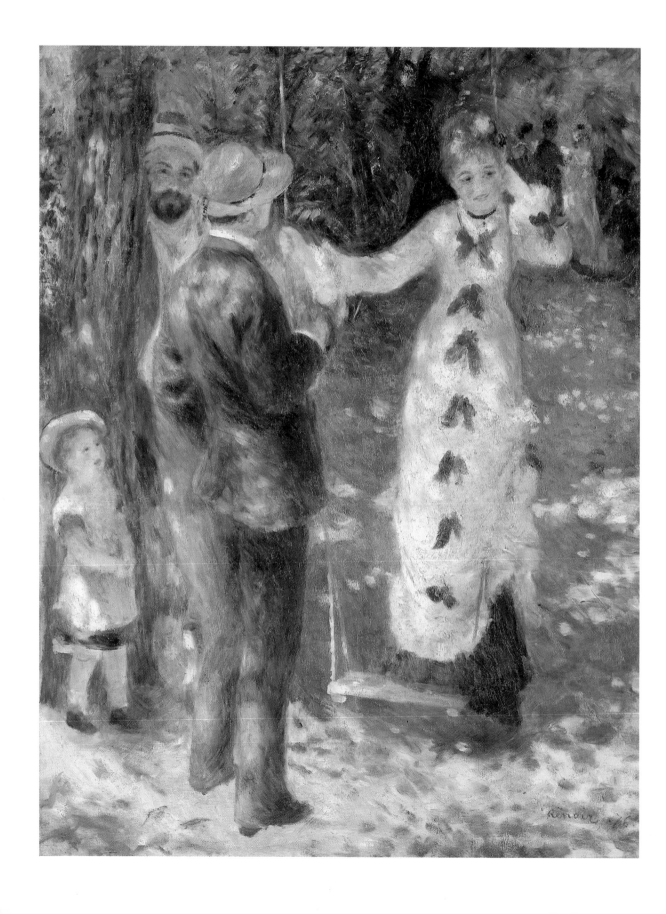

∧
**Pierre-Auguste Renoir
(1841-1919)**
Étude; torse, effet de soleil
Second Impressionist
Exhibition, 1876

Canvas
81 × 65
Gustave Caillebotte bequest,
1894
R.F. 2740

∧∧
**Camille Pissarro
(1830-1903)**
La Bergère, also known as *Jeune
fille à la baguette; paysanne assise*
1881

Canvas
81 × 64.7
Bequest of Comte Isaac
de Camondo, 1911
R.F. 2013

<
**Pierre-Auguste Renoir
(1841-1919)**
La Balançoire
1876
Third Impressionist
Exhibition, 1877

Canvas
92 × 73
Gustave Caillebotte
bequest, 1894
R.F. 2738

L'Etude; torse, effet de soleil, which reminded one hostile critic of "a pile of decomposing flesh", shows, by the iridescence of its blue-shadowed carnations, how far Renoir was able to push the study of colour. All the same, *Le Bal du Moulin de la Galette* and *La Balançoire* of 1876, which depict the working-class quarter of Montmartre where he lived, are probably the best examples of Renoir's Impressionism. Ambitious figure composition, complex light effects, absolute freedom of touch and intensity of colour (blues that are almost black, vivid greens and oranges), are the main features of these two masterpieces, which were so poorly received by Renoir's contemporaries.

Less than ten years separate *Le Bal du Moulin de la Galette* and Renoir's *Danses.* The similarity of the two themes accentuates the speed of Renoir's development, as well as the completeness of his 1880 rupture with the vague contours, complex treatment of space and shimmering colours of his Impressionist period. Curiously, the model for *Danse à la ville* was Suzanne Valadon, Utrillo's mother; the dancer in the other canvas was Aline Charigot, later Mme Renoir.

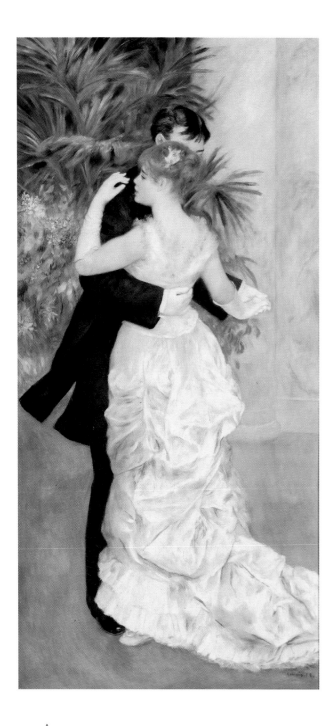

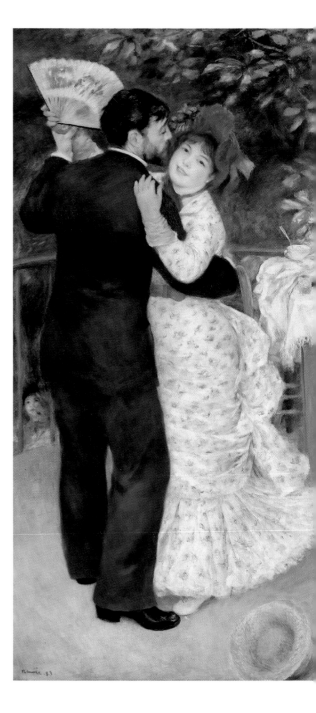

∧

**Pierre-Auguste Renoir
(1841-1919)**
Danse à la ville
1883

Canvas
180 × 90
Donation in lieu of payment
of death duty, 1978
R.F. 1978-13

∧

**Pierre-Auguste Renoir
(1841-1919)**
Danse à la campagne
1883

Canvas
180 × 90
Purchased in 1979
R.F. 1979-64

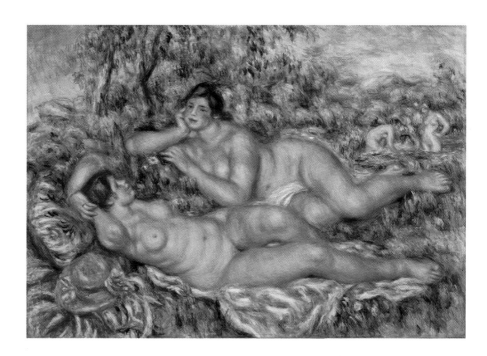

<

**Pierre-Auguste Renoir
(1841-1919)**
Baigneuses
1919

Canvas
110 × 160
Gift of the artist's sons, 1923
R.F. 2795

∨

**Pierre-Auguste Renoir
(1841-1919)**
Portrait de Julie Manet,
also known as *L'Enfant au chat*
1887

Canvas
65.5 × 53.5
Donation in lieu of payment
of death duty, 1999
R.F. 1999-13

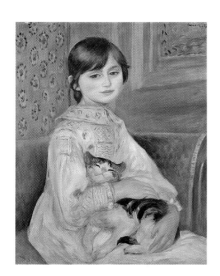

The two recently acquired *Danses* (one of which entered Orsay as a donation in lieu of payment of death duty, the other by purchase), along with *Les Jeunes Filles au piano,* several nudes and portraits and the *Baigneuses* (given by Renoir's sons after his death), are an incomparable demonstration of the final developments in Renoir's style. Although he became an invalid at the end of his life, it is clear that he never lost one iota of his exuberant sensuality.

Three new pictures by Renoir have further enhanced the Musée d'Orsay's collections in recent years. *Le Garçon au chat* painted in 1868 was purchased in 1992 with the assistance of Monsieur Philippe Meyer; it had belonged to Edmond Maître, a close friend of Bazille. In it we see the influence of Courbet and Manet on Renoir, a realist painter endowed with lively sensuality. The 1887 *Portrait de Julie Manet* or *L'Enfant au chat*, which entered the museum through donation in lieu of payment of death duty in 1999, is a good illustration of what could be called the artist's "Ingres" period. Finally the *Grand Nu* from the

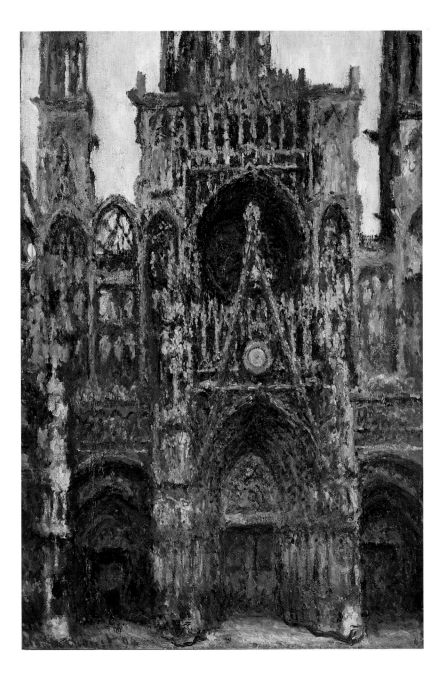

>
Claude Monet
(1840-1926)
Cathédrale de Rouen
1893-1894

Canvas
107 × 73
Bequest of Comte Isaac
de Camondo, 1911
R.F. 2002

Kahn-Sriber donation painted in 1907 shows the influence of Titian on Renoir at the height of his maturity.

Monet's career, which, like Renoir's, continued well into the 20th century, to some extent followed the various subjects he painted on his travels or around his different residences. The Orsay collection of nearly seventy paintings admirably represents every period of Monet's working life. The ten pictures from the Moreau-Nélaton donation show his beginnings, followed by the Argenteuil period. The Camondo bequest (fourteen paintings) includes the Vétheuil canvases, one from London and two from Giverny, that show the famous Japanese bridge *(Harmonie verte, Harmonie rose)* and four versions of the *Cathédrale de Rouen,* one of which had already been acquired in 1907.

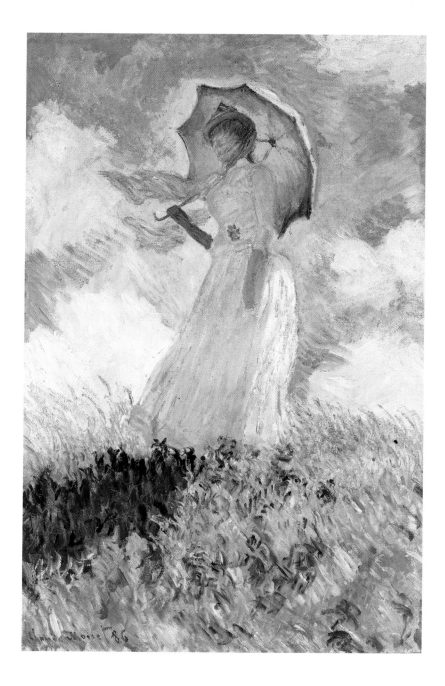

<
**Claude Monet
(1840-1926)**
Femme à l'ombrelle
1886

Canvas
131 × 88
Gift of Michel Monet,
the artist's son, 1927
R.F. 2621

As Monet explained to the critic Duret, one of the most faithful allies of the Impressionists, he worked "on figures in the open air... treated in the same way as landscapes". The two *Femmes à l'ombrelle* show how Monet's themes, his human figures, his façades of Rouen cathedral or even his pond at Giverny were used merely as a pretext to display the realities of colour and light as he perceived them.

A more recent donation in lieu of death duty has strengthened the representation of the Giverny period with the addition of a highly coloured canvas of *Le Jardin de Monet,* and the 1981 acquisition of the *Nymphéas bleus* testifies to the development of the painter right up to his final stages, which were so rich in lessons for the painters of the 20th century.

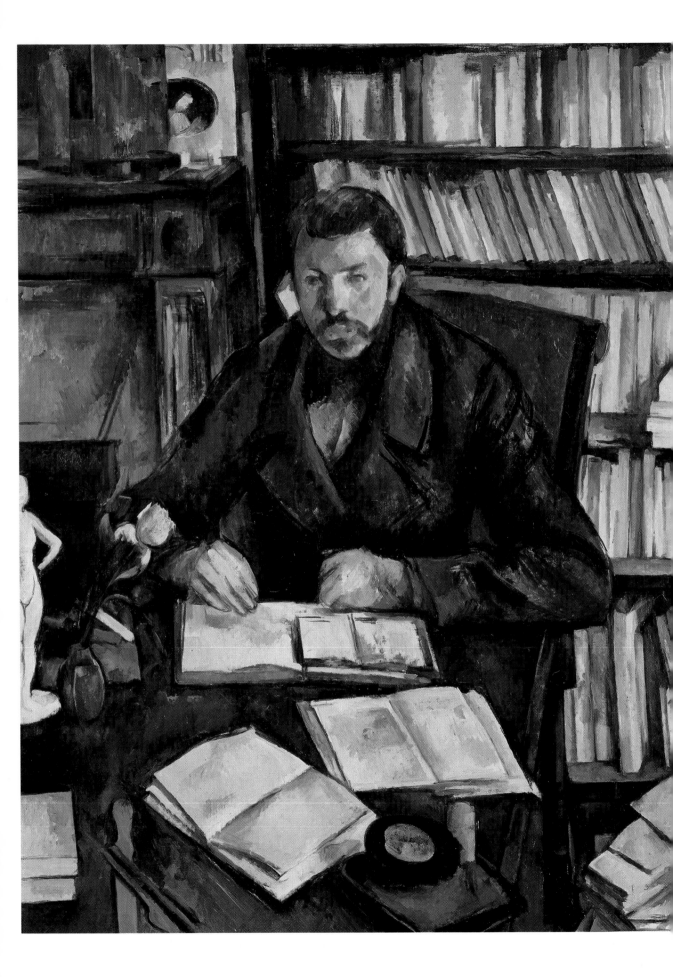

Post-Impressionism

The eighth and last Impressionist exhibition of 1886 was full of contradictions and promises for the future. On the artistic scene, the post-Impressionist years (1880-1900) were marked by the coexistence of the protagonists of the movement that had officially come into being in 1874 and an array of painters who were opposed to reproducing the "impression".

∧
**Paul Cézanne
(1839-1906)**
L'Avocat (L'oncle Dominique)
c. 1866

Canvas
65 × 54.5
Donation in lieu of payment
of death duty, 1991
R.F. 1991-21

<
**Paul Cézanne
(1839-1906)**
Gustave Geffroy (1855-1926)
1895

Canvas
110 × 89
Donation from Auguste Pellerin's
grand-daughter with reservation
of lifetime use, 1969; entered
collection in 2000
R.F. 1969-29

Monet, Renoir and Pissarro by no means exhausted the potential of Impressionism, and already by the 1880s a series of reactions to the movement had begun, headed by different painters. Some, like Cézanne, had been associated with the early days of the Impressionist adventure; others, like Gauguin, Van Gogh or Seurat, belonged to the next generation, or were even younger, like Toulouse-Lautrec or the nabis. Soon enough, it became expedient to refer to the crop of new artistic tendencies as "post-Impressionist"; they were highly diverse but all defined themselves in relation to Impressionism, generally reacting against it. Cézanne's construction and Gauguin's syntheticism were a response to the dissolution of forms, the logical conclusion of Monet's approach, while the divisionist rationalism of Seurat and the neo-Impressionists was directly opposed to Monet's spontaneity of touch. Redon's plunge into the inner world and the expression of his phantasmagoric visions is a response to the instantaneity of the impression, imprisoned by reality, while Van Gogh gives free rein to the suggestive powers of colour.

About thirty of Cézanne's paintings are exhibited at the Musée d'Orsay, covering every stage of his career. This unique collection comes mainly from bequests and donations (Caillebotte, Camondo, Pellerin, Gachet, Kaganovitch), impressive both in quality and quantity. To these have been added other works acquired more recently through donation in lieu of death duty, in 1978 (*Rochers près de Château noir* from the former Matisse collection) and 1982 (a group of twelve pictures from the former Pellerin collection, five of which have been allocated to Orsay, including the *Pastorale*). *L'Avocat* (*L'Oncle Dominique*) painted in 1866 also came through donation in lieu of death duty in 1991.

Dating from the start of Cézanne's career, *L'Avocat* portrays the artist's maternal uncle, Dominique Aubert, a familiar model who can be recognized in ten or so portraits

∧
**Paul Cézanne
(1839-1906)**
Pastorale or *Idylle*
1870

Canvas
65 × 81
Donation in lieu of payment
of death duty, 1982
R.F. 1982-48

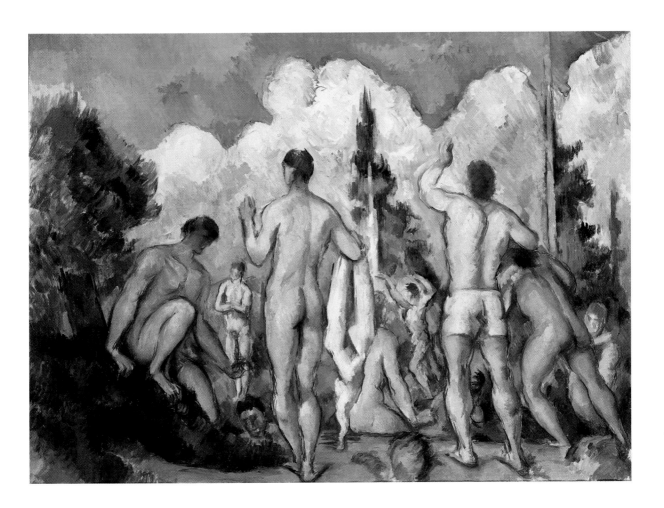

∧
**Paul Cézanne
(1839-1906)**
Baigneurs
c. 1890-1892

Canvas
60 × 82
Donation of Baroness Eva
Gebhard-Gourgaud, 1965
R.F. 1965-3

where he is depicted in a more or less imaginative way, all powerfully treated with a palette knife.

The *Pastorale* also belongs to what is known as the artist's "big-balled" manner where a powerful temperament tussling with violent conflicts is expressed on the formal level by a thick impasto and pronounced contrasts. Yet in choosing the classical theme of the *Pastorale*, a covert reference to Manet's *Le Déjeuner sur l'herbe*, Cézanne conveyed his admiration for the great Italian Baroque painters and embarked on the series of *Baigneuses* which was to obsess him throughout his life.

It was not until 1949 that a small version of the *Baigneurs* painted in 1890-1900 could be bought, followed three years later by the purchase of one of the artist's very first works, *La Madeleine* (c. 1868-1869), a fragment from the decoration of Le Jas-de-Bouffon, Cézanne's father's property at Aix.

<
**Paul Cézanne
(1839-1906)**
L'Estaque, view of
the bay of Marseilles
1878-1879

Canvas
59.5 × 73
Gustave Caillebotte
bequest, 1894
R.F. 2761

>
**Paul Cézanne
(1839-1906)**
Les Joueurs de cartes
c. 1890-1895

Canvas
47.5 × 57
Bequest of Comte Isaac
de Camondo, 1911
R.F. 1969

<
**Paul Cézanne
(1839-1906)**
Le Pont de Maincy
c. 1879

Canvas
58.5 × 72.5
Purchased with the
accumulated interest
on an anonymous Canadian
donation, 1955
R.F. 1955-20

We are indebted to Caillebotte for the first Cézannes that entered the national collections, the *Cour de ferme à Auvers* and the splendid *Estaque,* where the artist's mother owned a property. This landscape, built up brushstroke by brushstroke and immortalized in a light that suspends all movement, has nothing in common with the seascapes of the painter's Impressionist colleagues. The *Pont de Maincy,* which was painted during the same period and deals with a favourite Impressionist theme, shows how far Cézanne had distanced himself from a style that did not match his innermost preoccupations, namely the primacy of spatial organisation, the construction of forms by brushstroke, and the stubborn determination to transcend the temporal contingencies of the subject. These elements are not yet visible in the seven paintings which entered the collection thanks to two gifts from Paul Gachet in 1951 and 1954, all painted around 1873, a period strongly marked by the influence of Pissarro (notably *La Maison du docteur Gachet* or *Le Carrefour de la rue Rémy à Auvers*). As well as *Le Portrait d'Achille Emperaire* from the former A. Pellerin collection, the Musée d'Orsay also owns two historic paintings which represented Cézanne's work at the first Impressionist exhibition in 1874: *Une moderne Olympia* from the Gachet donation and *La Maison du pendu* from the splendid Camondo bequest of 1911. The famous *Vase bleu,* one of the five versions of the *Joueurs de Cartes* –

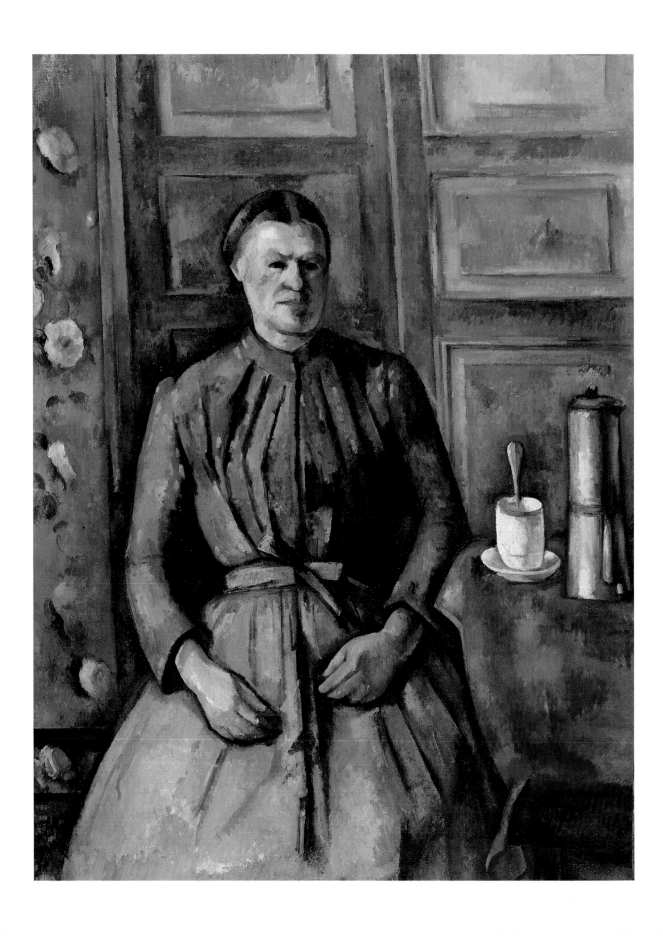

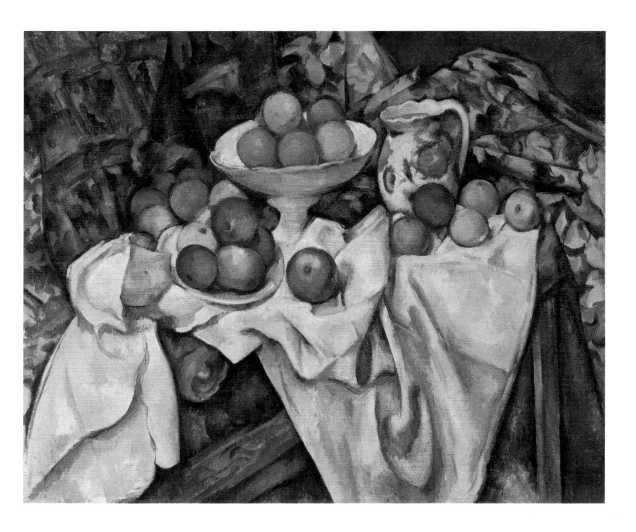

a superb study for one of the two figures was given to the museum by Mr Heinz Berggruen in 1997 – and the imposing *Pommes et oranges* dated 1890 were also part of the Camondo bequest. The last picture together with three still lifes from the Auguste Pellerin bequest (*Nature morte aux oignons*, *Nature morte à la soupière*, and *Nature morte au panier*) and *La Femme à la cafetière* form a unique group that makes it possible to follow the painter's development from 1877 to his maturity in the 1890s.

"I want to amaze Paris with an apple", the young Cézanne said, according to the famous critic Gustave Geffroy, the first owner of *Pommes et oranges*. Reconstructing the model or the object in space by using more than one viewpoint, questioning the innermost structures of the subject, building it up from geometry and colour, studying the way light fell on it to convey the fullness of the sensation: this was what Cézanne set out to do in his portraits and still lifes.

∧
**Paul Cézanne
(1839-1906)**
Pommes et oranges
c. 1895-1900

Canvas
74 × 93
Bequest of Comte Isaac
de Camondo, 1911
R.F. 1972

<
**Paul Cézanne
(1839-1906)**
La Femme à la cafetière
c. 1890-1895

Canvas
130.5 × 96.5
Gift of M. and Mme Jean-Victor
Pellerin, 1956
R.F. 1956-13

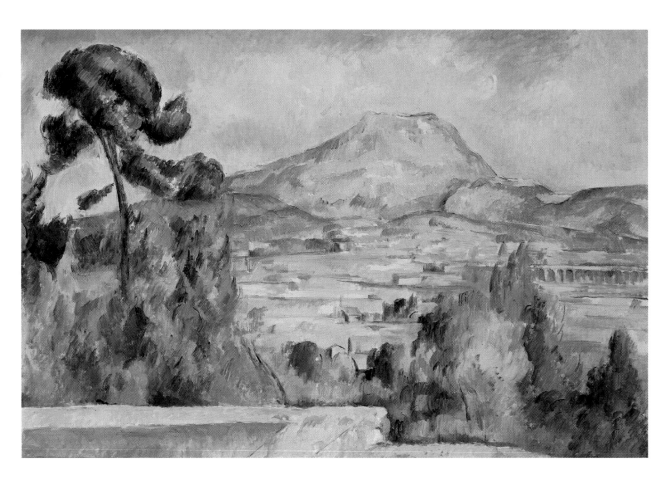

∧
**Paul Cézanne
(1839-1906)**
Montagne Sainte-Victoire
c. 1887-1890

Canvas
65 × 92
Donation from Auguste
Pellerin's grand-daughter
with reservation of lifetime
use, 1969; entered collection
in 2000
R.F. 1969-30

At the beginning of the year 2000, two paintings from the height of the artist's mature period entered the museum with the lapse of the reserve of lifetime use on the donation made in 1969 by Auguste Pellerin's grand-daughter: *La Montagne Sainte Victoire* from around 1890 and *Le Portrait de Gustave Geffroy* painted in 1895-1896. These two crucial works splendidly round off the already outstanding collection of works by Cézanne exhibited at Orsay. For the museum did not have one of the finest of the more than thirty representations of the Aix-en-Provence *Montagne* immortalised by the artist, or the astonishingly modern portrait of the great art critic Gustave Geffroy, shown here in his study.

"When colour is at its richest, form is at its fullest," Cézanne liked to say. By asserting the autonomy of the painted object in this way, he opened the way wide to cubism and abstraction.

It is also in relation to Impressionism that the art of Van Gogh was first defined during his stay in Paris from February 1886 to February 1888; his discovery of the movement led to the blossoming of his own art, represented in the Orsay collections by some twenty paintings. *La Tête de paysanne hollandaise* painted in 1884, is the sole example of Van Gogh's earlier work; this period with its dark, heavily-applied paint was dominated by the famous *Potato Eaters* (Van Gogh Museum, Amsterdam, 1885), for which this is a preparatory study. It is also the only painting by Van Gogh to have been bought by the French Musées Nationaux, in 1954. Apart from the state contribution towards the purchase of the *Église d'Auvers,* we owe all our Van Goghs to various gifts and bequests, notably the two separate Gachet donations. Five paintings illustrate the period in Paris. Van Gogh, who had come to join his brother Theo, found himself swept up in an artistic milieu seething with excitement and new ideas. The immediate effect of his stay was the irreversible lightening of a palette that had been dominated by dark ochres and sepia browns, as demonstrated by *La Guinguette* and *Le Restaurant de la Sirène*, which are openly Impressionist in spirit. But Van Gogh, whose ardent temperament had only been waiting for a suitable technique to reveal itself, very soon discovered the expressive powers of pure colour applied in divided, juxtaposed brushstrokes, as in the bunch of flowers in *Fritillaires*, the *Autoportrait* of 1887 and the famous *Italienne*. The composition of this last painting, which anticipates the boldness of the Fauves and expressionists, also reveals the decisive influence of the Japanese prints which the artist had recently discovered.

From his time in Arles we have five canvases including *L'Arlésienne* and *Salle de danse*, which show the new synthetist and cloisonnist direction of Van Gogh's style under the influence of Gauguin and Emile Bernard.

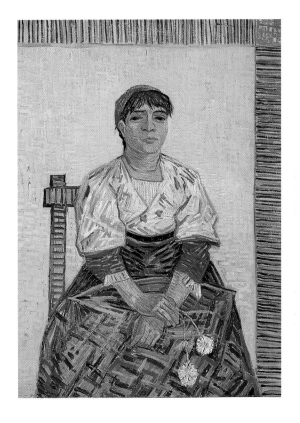

∧
**Vincent Van Gogh
(1853-1890)**
L'Italienne
1887

Canvas
81 × 60
Donation of Baroness Eva
Gebhard-Gourgaud, 1965
R.F. 1965-14

<

**Vincent Van Gogh
(1853-1890)**
*La Chambre de Van Gogh
à Arles*
1889

Canvas
57.5 × 74
Former Matsukata collection;
entered collection in 1959
pursuant to peace treaty
with Japan
R.F. 1959-2

>

**Vincent Van Gogh
(1853-1890)**
Portrait de l'artiste
1887

Canvas
44 × 35
Jacques Laroche donation
with reservation of lifetime
use, 1947; entered collection
in 1976
R.F. 1947-28

<

**Vincent Van Gogh
(1853-1890)**
La Méridienne or *La Sieste*
1889-1890
Painted after a woodcut
reproducing a drawing
by Jean-François Millet

Canvas
73 × 91
Donation from Mme Fernand
Halphen with reservation of
lifetime use, 1952; entered
collection in 1963
R.F. 1952-17

<

**Vincent Van Gogh
(1853-1890)**
*L'Église d'Auvers-sur-Oise,
vue du chevet*
1890

Canvas
94 × 74.5
Purchased with the assistance of
Paul Gachet and an anonymous
Canadian donation, 1951
R.F. 1951-42

v

**Vincent Van Gogh
(1853-1890)**
Le Docteur Paul Gachet
1890

Canvas
68 × 57
Gift of Paul and Marguerite
Gachet, the model's children,
1949
R.F. 1949-16

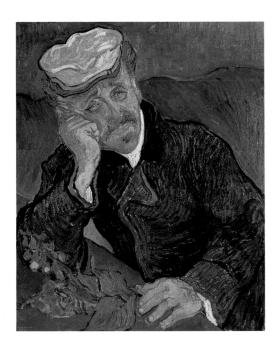

Vincent dreamt of setting up a studio in the south, and at his request Gauguin went to Arles where they stayed together from October to December 1888. This stay was a source of fruitful exchanges between the two artists who had a mutual influence on one another and enjoyed depicting the same motifs. Thus Van Gogh came to paint the path in the Arles cemetery of Les Alyscamps several times, while Mme Ginoux, the *Arlésienne* of whom Van Gogh painted two different versions, appears in a painting by Gauguin entitled *Au café* (Moscow, Pushkin Museum). The dramatic episode of the lopped-off ear put an end to that experiment.

La Nuit étoilée, painted in September 1888, was added to the collection in 1995 following the lapse of the reserve of lifetime use on the gift from M. and Mme Robert Kahn Sriber in memory of M. and Mme Fernand Moch in 1975. "I am now quite resolved to paint a starry sky…" Van Gogh wrote to his sister in September 1888. The subject had been obsessing him for some weeks, and the artist painted this canvas at night by the light of a gas burner, a tragic transposition of his hopes and torments.

The 1889 *Autoportrait*, *La Chambre à Arles* and *La Méridienne* are charged with a special emotional intensity as Van Gogh painted all three canvases at the Hôpital Saint-Jean at Saint-Rémy, where he lodged as a patient.

"Here colour must make the thing, and by giving a greater style to things through simplification must be suggestive of rest or sleep in general. Really looking at the picture must soothe the head or rather the imagination," Vincent wrote to his brother Theo while painting the first version of *Chambre à Arles* in 1888. A year later, still living as a patient at the hospital at Saint-Rémy, he set out to make two replicas of it. A retrospective vision of that room was the focus of all his dreams, and this picture with its swaying perspective exposes a flagrant void. Like the *Autoportrait* painted in the same year, it shows what an emotional exorcism the pursuit of painting was for Van Gogh in his illness.

Doctor Gachet, an extraordinary man who had written a treatise on melancholia and who was a specialist in nervous illnesses, welcomed artists at his house in Auvers-sur-Oise. Pissarro, Guillaumin and Cézanne were among his friends. In June 1890 he took Van Gogh in and helped him until the artist committed suicide in July of the same

∧

**Georges Seurat
(1859-1891)**
Trois études pour les Poseuses
1886-1887

Wood
each panel: 25 × 16
Purchased in 1947
R.F. 1947-13 to -15

∨

**Georges Seurat
(1859-1891)**
Port en Bessin, avant-port, marée haute
1888

Canvas
67 × 82
Purchased with the accumulated interest
on an anonymous Canadian donation, 1953
R.F. 1952-1

year. It was while with him that the painter produced his most expressionist works, such as the pathetic *Église d'Auvers* which leaps out like a cry in the night. Thus the seven paintings by Van Gogh from the Gachet donation complete the final pre-Fauve and expressionist trend of Van Gogh's art in his last period at Auvers-sur-Oise.

A revival of interest in the neo-Impressionist school, which for years was poorly represented in the national collections, came somewhat too late to fill various irremediable gaps. Most of the masterpieces by the movement's leader, Georges Seurat, were sold abroad in the 1920s. In view of this dismaying haemorrhage, Signac appealed to the American collector John Quinn who in 1924 bequeathed *Le Cirque*, Seurat's last painting, left unfinished at his death in 1891. In Paris we have to make do with three studies or "sketches", all very interesting, for *La Baignade à Asnières* and *Un dimanche après-midi à l'île de la Grande Jatte*, two masterly works. Fortunately the purchase in 1947 of three very advanced studies for the large picture *Poseuses* and that in 1952 of *Port-en-Bessin*, part of a series painted in Normandy in 1888, make possible a better appreciation of the master's art in his maturity.

The three studies for the large painting *Poseuses* which kept the artist occupied from 1886 to 1888 combine the quintessence of Seurat's art. Technical perfection worthy of a miniaturist in the service of an implacable scientific logic does not exclude the extreme

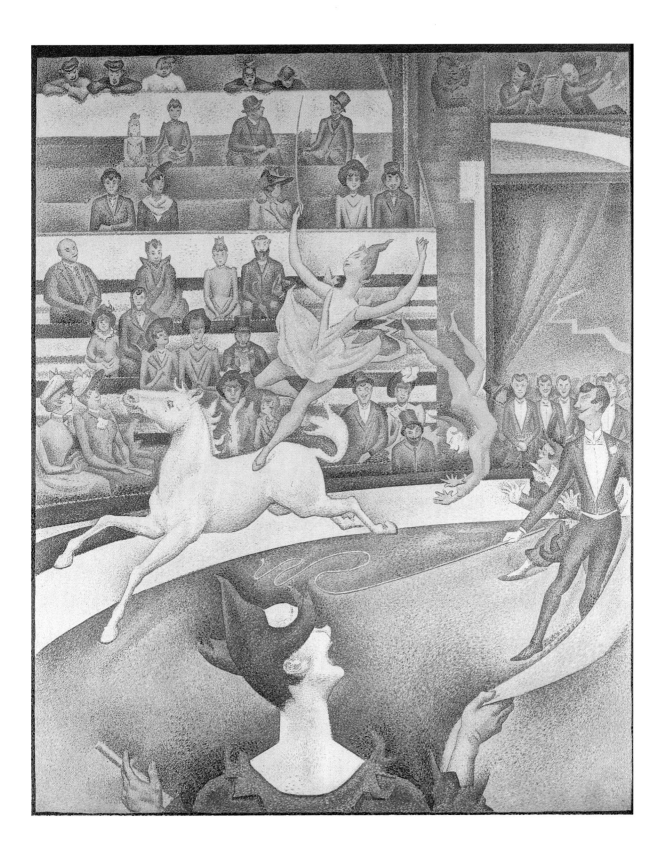

^
**Georges Seurat
(1859-1891)**
Le Cirque
Salon des Indépendants,
1891

Canvas
185.5 × 152.5
John Quinn bequest, 1924
R.F. 2511

poetry of these figures, which show the painter's profoundly classical temperament.

The application of the optical mixture of colours in accordance with the theories of Chevreul and Rood, the strict composition of these three canvases and their skilful luminosity give credence to Seurat's claim to be a great master. *Le Cirque* with its acidic colours and skilful

<
**Paul Signac
(1863-1935)**
La Bouée rouge,
Saint-Tropez
1895

Canvas
81 × 65
Donation from Dr Pierre Hébert
with reservation of lifetime
use, 1957; entered collection
in 1973
R.F. 1957-12

>
**Paul Signac
(1863-1935)**
Jeunes Provençales au puits
(decoration for a panel
in semi-darkness)
1892
Salon des Indépendants,
1893

Canvas
195 × 131
Purchased in 1979
R.F. 1979-5

rhythms reveals the influence of Charles Henry's theories on the dynamics of the lines in the final years of Seurat's short career: he died at the age of thirty-two.

It is also a matter of regret that some of Signac's most important paintings were not acquired in time to prevent their loss abroad. Nonetheless, his work is abundantly represented at the Musée d'Orsay, from the Impressionist landscape *La Route de Gennevilliers* (1883) to the imposing *Port de La Rochelle* (1921) with its broad, square brushstrokes.

In *La Seine à Herblay*, painted in 1889, Signac was already applying strict divisionism under the influence of Seurat. When he settled in Saint-Tropez in 1892 he discovered the Midi where the light transfigures forms and colours. After pushing his theoretical research to the extreme in *Jeunes Provençales au puits,* in which he systematically exploited the laws of the simultaneous contrast of colours and the optical mixture advocated by Seurat, he found a new spontaneity in the gradual broadening of his brushstrokes, superbly exemplified in *La Bouée rouge.*

<

**Henri-Edmond Cross
(1856-1910)**
Les Iles d'Or, Iles d'Hyères
(Var)
c. 1891-1892

Canvas
59 × 54
Purchased in 1947
R.F. 1977-126

>

**Henri-Edmond Cross
(1856-1910)**
L'Air du soir
1893-1894

Canvas
116 × 165
Donation from Mme Ginette
Signac with reservation of
lifetime use, 1976; lifetime
use renounced, 1979
R.F. 1976-81

∨

**Henri-Edmond Cross
(1856-1910)**
La Chevelure
c. 1892

Canvas
61 × 46
Purchased in 1969
R.F. 1977-128

In 1996 a major donation in lieu of death duty rounded off the representation of Signac at the Musée d'Orsay: *Les Andelys: la Berge*, a picture painted by the artist in June 1886, the crucial year when he adopted the theories of the division of colour and optical mixture. This work is part of a series of ten landscapes painted at Les Andelys, where Signac lived for three months. Shown the following year at the third exhibition of the Peintres Indépendants, it was never exhibited again in the artist's lifetime, remaining in the collection of his mother Héloïse and her descendants.

A donation by Ginette Signac in 1976 considerably enriched the neo-Impressionist collections, with (among other works) two paintings by Signac, *Venise, la voile verte* and *Femme sous la lampe*, and two by Henri-Edmond Cross, including *L'Air du soir* (1894) with its symbolist echoes derived from Puvis de Chavannes. Cross was already better represented than his fellow pupils thanks to major purchases made between 1947 and 1969. These include *Les Iles d'or*, the *Portrait de Mme Cross* and *La Chevelure*, three works representative of the subtle pointillist technique of the artist in 1891 to 1892, when he achieved an especially original poetic balance between realism and abstraction.

<
**Théo van Rysselberghe
(1862-1926)**
Voiliers et estuaire
c. 1892-1893

Canvas
50 × 61
Purchased in 1982
R.F. 1982-16

>
**Henri de
Toulouse-Lautrec
(1864-1901)**
Jane Avril dansant
1891

Cardboard
85.5 × 45
Antonin Personnaz
bequest, 1937
R.F. 1937-37

v
**Georges Lemmen
(1865-1916)**
Plage à Heist
1891

Wood
37.5 × 46
Purchased in 1987
R.F. 1987-35

Les Batteurs de pieux and *Une rue de Paris sous la Commune* illustrate the realist, social and anarchist inspiration of Maximilien Luce. He also painted portraits of his friend Cross and the critic Félix Fénéon, first editor of the *Revue Indépendante*, the mouthpiece of Seurat's followers, then of the *Revue blanche,* which supported the nabi movement in the 1890s. Luce's urban inspiration is also represented by a view of *Notre-Dame de Paris* and by a wide vista showing *Le Louvre et le Pont neuf la nuit.* The latter painting, handled in a delicate pointillist manner, is a departure from the social realism he normally practised.

Less well-known painters of the neo-Impressionist tendency such as Angrand, Hayet, Dubois-Pillet, Lucien Pissarro (son of the great Camille) and Henri Petitjean are also present at Orsay. *L'Homme à la barre* and *Voiliers et estuaire* by Theo van Rysselberghe illustrate the Belgian continuation of pointillism, well represented in Brussels in the 1890s by the famous group Les Vingt (Les XX), precursor of the Libre Esthétique. The Belgian artist George Lemmen also belonged to that movement, and his *Portrait de la Femme de l'artiste* and *Plage à Heist* reveal the intimism and feeling for colour variations of this subtle painter who exhibited with the group Les Vingt (Les XX).

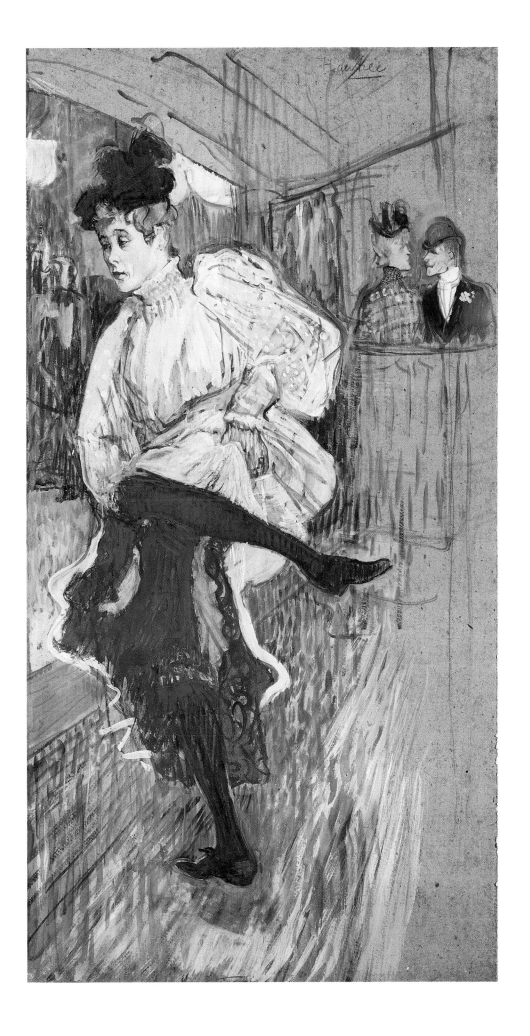

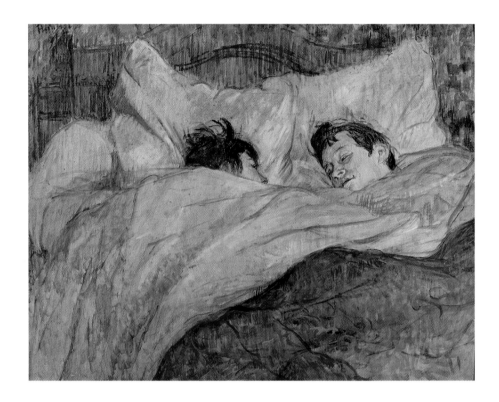

<

Henri de Toulouse-Lautrec (1864-1901)
Le Lit
c. 1892

Cardboard on a parquet panel
54 × 70.5
Antonin Personnaz
bequest, 1937
R.F. 1937-38

v

Henri de Toulouse-Lautrec (1864-1901)
La Clownesse Cha-U-Kao
1895

Cardboard
64 × 49
Bequest of Comte Isaac de Camondo, 1911
R.F. 2027

With its collection of eighteen oils on canvas or *à l'essence sur carton* (turpentine on hardboard), the Musée d'Orsay offers a rich panorama of the work of Toulouse-Lautrec, to which the astonishing museum at Albi is also wholly devoted. This reminder must be made, as the work of the Impressionist and post-Impressionist masters is not sufficiently well represented in provincial museums. Apart from the two imposing panels made to decorate La Goulue's booth at the Foire du Trône in 1895, the Orsay collection consists of medium-sized works, mostly portraits. From pure portraits such as *Justine Dieuhl* to rapid sketches of servant girls and toilet scenes in the tradition of Degas, the various aspects of the artist's inspiration are well represented, particularly his evocation of the world of show business with portraits of La Goulue, Valentin le Désossé, Cha-u-Kao, Jane Avril and Henry Samary. A further work which entered the museum recently through donation in lieu of death duty, *Seule* demonstrates the artist's technical virtuosity in the service of an unvarnished realism, in a poignant vision which is

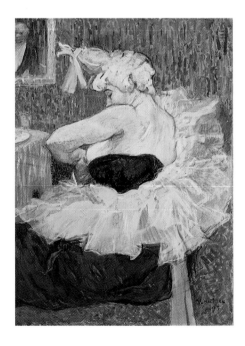

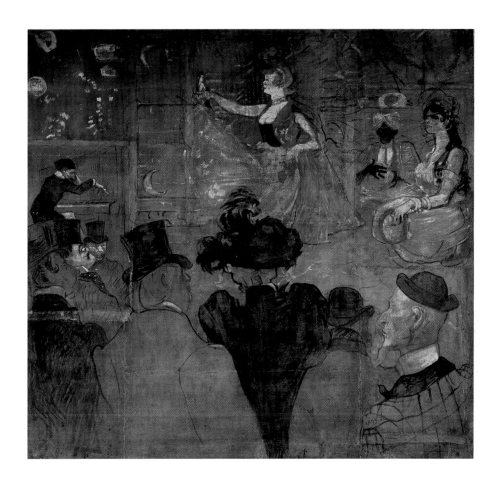

>
Henri de Toulouse-Lautrec (1864-1901)
La Danse mauresque
or *Les Almées*
Panel for La Goulue's booth at the Foire du Trône, Paris
1895

Canvas
285 × 307.5
Purchased in 1929
R.F. 2826

∨
Henri de Toulouse-Lautrec (1864-1901)
La Toilette
1896

Cardboard
67 × 54
Pierre Goujon bequest, 1914
R.F. 2242

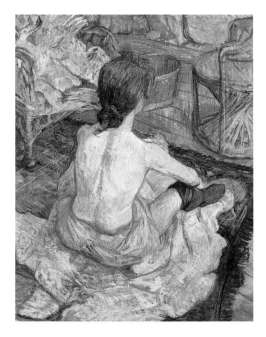

similar in spirit to the extraordinary lithographic series from 1895 entitled *Elles*.

All but three of these works come from bequests or donations made between 1902 to 1953, with the four works including *Jane Avril dansant* and *Le Lit* from the Personnaz bequest an outstanding group.

A living chronicle of the night-time Paris of brothels and cabarets, the work of Toulouse-Lautrec brings the stars of the stage and dance-hall back to life – *Jane Avril dansant* drawn from life at the Moulin Rouge, *La Clownesse Cha-U-Kao* adjusting her clothes in her box. When La Goulue left the Moulin Rouge to take up residence at the Foire du Trône at Neuilly she asked her friend to decorate the booth where she would be performing. He did so with two large canvases painted in 1895 where he depicted her as an Egyptian dancing-girl alongside her famous partner, Valentin le Désossé. Painted rapidly from behind in front of the footlights, we can recognize the critic Félix Fénéon, Toulouse-Lautrec's long-term friend Jane Avril, the English writer Oscar Wilde, at that time on trial for homosexuality, and the photographer Paul Sescau.

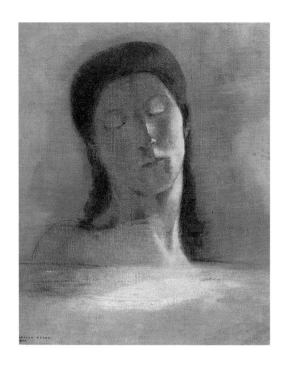

For a long time Odilon Redon, a crucial figure for the whole post-Impressionist generation, was neglected by the national collection, which until recently only contained six canvases: two bunches of flowers and four figure paintings. These included his posthumous portrait of Gauguin; the portrait of Mme Redon, *Les Yeux clos*, the only work purchased in the artist's lifetime, in 1904; and *Ève* which entered the museum recently through donation in lieu of death duty. The museum's selection of pastels including masterpieces such as *Parsifal*, *Le Sacré-Cœur*, *Le Char d'Apollon* and *Le Bouddha* made up for this relative impoverishment.

Therefore the bequest from Mme Suzanne Redon in 1984 constituted a major event. Hundreds of drawings by Redon were given to the Louvre and the Musée d'Orsay received about sixty pictures, including a youthful *Autoportrait*, a charming *Portrait d'Ari enfant*, various religious, mythological or literary scenes (*Le Sommeil de Caliban*) and a unique set of landscapes. Among the pastels *Jeanne d'Arc*, *La Couronne* and above all the famous *Coquille* display Redon's incomparable mastery of this subtle medium.

∧
∧
**Odilon Redon
(1840-1916)**
Les Yeux clos
1890

Oil on cardboard
44 × 36
Purchased in 1904
R.F. 2791

∧
**Odilon Redon
(1840-1916)**
La Coquille
1912

Pastel
52 × 57.8
Bequest of Mme Ari Redon,
in fulfilment of her husband's
wishes, 1982
RF 40494

>
**Odilon Redon
(1840-1916)**
Le Bouddha
c. 1905

Pastel on beige paper
90 × 73
Purchased in 1971
RF 34555

∧
**Odilon Redon
(1840-1916)**
*Bouquet de fleurs
des champs*
1912

Pastel on buff-coloured paper
57 × 35
Gift of the Association of
Friends of the Louvre, 1954
RF 30570

<
**Odilon Redon
(1840-1916)**
Arbre sur fond jaune,
decoration for dining
hall at the Château
de Domecy
1901

Canvas
249 × 185
Donation in lieu of payment
of death duty, 1988
R.F. 1988-30

In 1899, attracted by the new ideas aimed at developing interior decoration, Redon followed the example of the nabi painters in embarking on a vast pictorial programme intended for the dining-hall of the Château de Domecy in the department of Yonne. *Arbres sur fond jaune* is one of the seven large panels, complemented by eight smaller ones, that made up this sequence which was completed in October 1901. In these panels Redon used his research into chromatic harmony in a very unusual way, mixing real and imaginary flora and fauna. We have Baron de Domecy to thank for this exceptional commission to the artist; he had been one of the Redon's first collectors and patrons, from 1893 on. The portrait of *La Baronne de Domecy*, the baron's wife, painted by Redon in February 1900, rounds off this remarkable set of works, and was bought by the Musée d'Orsay in 1994 with the assistance of Philippe Meyer.

A special place in the museum is reserved for Henri Rousseau, known as *le Douanier*. This marginal painter,

∧

Henri Rousseau,
known as **le Douanier**
(1844-1910)
La Charmeuse de serpents
Salon d'Automne, 1907

Canvas
169 × 189.5
Jacques Doucet bequest, 1936
R.F. 1937-7

a Paris customs employee, is represented by two major paintings, since *La Guerre* is now exhibited at the Musée National d'Art Moderne at the Centre Georges Pompidou: *Portrait de Femme* and *La Charmeuse de serpents*. They demonstrate the great originality of a painter who intrigued Pissarro and Gauguin, amused Jarry and delighted Apollinaire and Picasso.

Douanier Rousseau is a figure who cannot be pigeon-holed: a self-taught artist and for a long time an amateur painter like Gauguin, he used to say that he had been influenced by the very official painter Gérôme. But his liking for paradox is well known, and the only label that suits him is "independent". Rousseau drew inspiration from scrapbook images, old photos and botany hand-books, which supplemented his visits to the Jardin des Plantes. In *La Charmeuse de serpents* he has created a strange universe with echoes of symbolism: mystery is decked out with the falsely ingenuous charms of naivety in an unprecedented proliferation of decoration and colour.

∧
**Paul Gauguin
(1848-1903)**
Les Alyscamps, Arles
1888

Canvas
91.5 × 72.5
Gift of Comtesse Vitali in
memory of her brother,
Vicomte Guy de Cholet, 1923
R.F. 1938-47

>
**Paul Gauguin
(1848-1903)**
La Belle Angèle,
Mme Satre
1889

Canvas
92 × 73
Gift of Ambroise Vollard, 1927
R.F. 2617

A desire for exoticism and a certain non-conformist bent were characteristics that Le Douanier Rousseau shared with Gauguin. The latter, after starting off as an Impressionist Sunday painter influenced by Pissarro, escaped to Brittany to get away from the constraints of the capital. It was at Pont-Aven between the summer of 1886 and the autumn of 1888 that a completely new style evolved, derived from the confrontation between a very young painter who enjoyed theoretical ideas, Émile Bernard, and Gauguin, longing for exile, wildness and primitivism. Together, they contrived a form of synthetic painting, breaking with traditional perspective in canvases filled with bright colours and ringed by flat tints: hence the name of "cloisonnism" given to their technique. They drew their inspiration from popular imagery, Japanese prints and local traditions that were still very much alive, especially peasant scenes (harvest, seaweed gathering, washerwomen). The group of painters that grew up around Bernard and Gauguin at Le Pouldu in 1889 was quickly reinforced by the arrival of new followers such as Laval, Sérusier, Schuffenecker, Séguin, Roy and the Dutchman Meyer de Haan. Gauguin was accepted as the leader of this new school at the exhibition of the "synthetic-symbolist" group at the Café Volpini in June 1889, a fringe event at the Universal Exhibition held in Paris across from the newly erected Eiffel Tower.

The museum's collection of paintings from the Pont-Aven school is particularly characteristic of the development of public taste , and of the incomprehension which dogged this style of painting until the 1950s. It was not until 1923, twenty years after his death, that Gauguin's work entered the museum with *Les Alyscamps*, a picture painted in the autumn of 1888 in the company of Vincent Van Gogh, and *Femmes de Tahiti*. Four years later *La Belle Angèle*, a painting which had belonged to Degas and is particularly representative of the Breton period because of its primitivism, cloisonnism and symbolism, was offered as a gift by the dealer Ambroise Vollard, who had made a contract with the artist in his

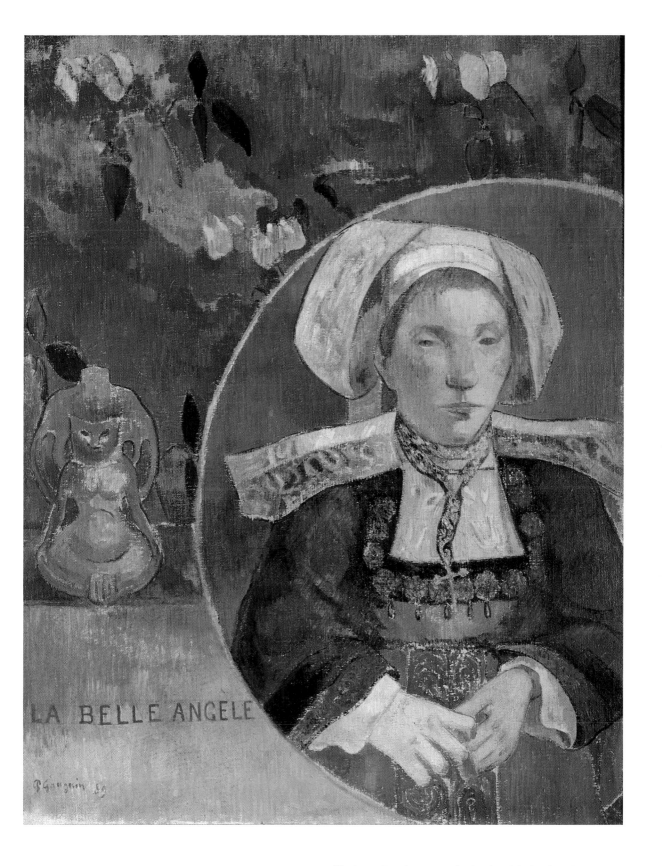

LA BELLE ANGÈLE

P.Gauguin 89

lifetime. But it was only in the 1950s that interest in Gauguin's Breton style and the Pont-Aven school in general was renewed, as if the importance of the post-Impressionist movements in the evolution of 20th-century painting was realized at that time. The neo-Impressionists and the nabis enjoyed a parallel return to favour.

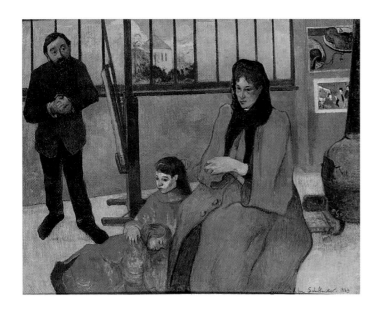

<

**Paul Gauguin
(1848-1903)**
La Famille Schuffenecker
1889

Canvas
73 × 92
Former Matsukata collection;
entered collection in 1959
pursuant to the peace treaty
with Japan
R.F. 1959-8

**Émile Bernard
(1868-1941)**
Madeleine au bois d'amour,
Madeleine Bernard,
the artist's sister
1888

Canvas
138 × 163
Purchased in 1977
R.F. 1977-8

∨

**Émile Bernard
(1868-1941)**
Moisson au bord de la mer
1891

Canvas
70 × 92
Purchased in 1982
R.F. 1982-52

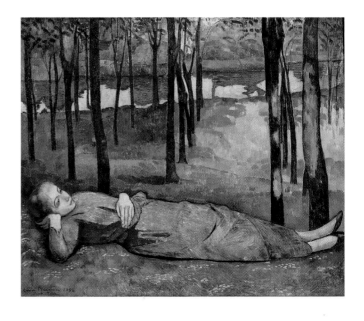

**Paul Sérusier
(1864-1927)**
Le Talisman
1888

Wood
27 × 21.5
Purchased with the participation
of M. Philippe Meyer through the
Lutèce Foundation, 1985
R.F. 1985-13

<
**Paul Sérusier
(1864-1927)**
Ève bretonne or *Mélancolie*
1890

Canvas
72.5 × 58.5
Donation from Henriette
Boutaric with reservation of
lifetime use, 1980; entered
collection in 1983
R.F. 1981-5

The recent purchase of *Madeleine au bois d'amour* and *La Moisson au bord de la mer* has restored Émile Bernard to his rightful place in the conception of the new style worked out at Pont-Aven during the summer of 1888. The more recently acquired *Les Baigneuses à la vache rouge,* painted that same year as part of a triptych which is unfortunately dismembered at present, demonstrates the crucial influence of Cézanne on this artist who in his critical writing was also one of the first defenders of the painting of the Aix-en-Provence master.

Paul Sérusier is now exceptionally well represented thanks to the donation and bequest of Mlle Boutaric, the artist's heir, who died in 1983. The seven paintings, including *Ève bretonne* and *Les Laveuses à la Laïta* show the symbolist and synthetic aspect of this artist; the Musée d'Orsay also bought his famous *Le Talisman* in 1985 with the help of an anonymous donor.

"How do you see that tree?" Gauguin had asked in a corner of the Bois d'Amour. "It's green? Then put in green, the most beautiful green in your palette; and this shadow, is it more blue? Don't be afraid to paint it as blue as you can…" As the quintessence of Gauguin's teaching through the brush of Sérusier, *Le Talisman* – "painted to Gauguin's instructions at Pont-Aven in October 1888" as the handwritten inscription on the back of this little wooden panel testifies – is first and foremost a manifesto in favour of the freedom to dare to anything that will pulverise the old constraints of realism and reclaim the autonomy of the painted object. No better transition between the Pont-Aven school and the nabi movement could be conceived of than this little picture, whose historical importance has been stressed by Maurice Denis himself in his *Théories*.

Although the museum still lacks a painting dating from Gauguin's stay in Martinique in 1887, we can judge of his visits to Tahiti through a set of paintings of excellent quality demonstrating the synthetic, decorative, primitive, highly colourful style he developed in the tropics. These include *Le Repas*, a genuine masterpiece from his first period in Tahiti, *Arearea* and *Vairumati*, two paintings which focus on the myths of the native religion, *Le Cheval blanc* and *L'Or de leur corps*, a canvas painted on the Marquesas Islands.

In 1994, the museum's collection of Gauguin self-portraits was enriched by the purchase, with the assistance of Philippe Meyer and patronage from Japan, of *Le Portrait de l'artiste au Christ jaune,* painted in 1890-1891. This work lies between the *Autoportrait* dating from Gauguin's return to Paris in 1894, with his Tahitian painting *Manau-Tupapau* or *L'Esprit des morts veille* in the background, and the *Autoportrait à l'ami Daniel* from 1896, in which the artist painted himself with the painter Daniel de Monfreid, a lifelong friend who supported him psychologically and financially to the end of his days. *L'Autoportrait au Christ*

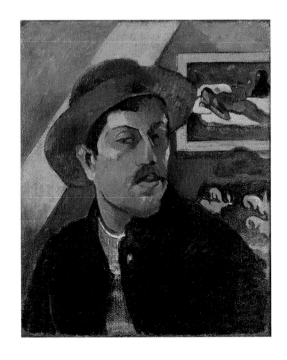

<

Paul Gauguin
(1848-1903)
Le Repas
1891

Canvas
73 × 92
Donation from M. and Mme
André Meyer with reservation of
lifetime use, 1954; lifetime use
renounced, 1975
R.F. 1954-27

v

Paul Gauguin
(1848-1903)
Arearea (Joyeusetés)
1892

Canvas
75 × 94
Bequest of M. and
Mme F. Lung, 1961
R.F. 1961-6

v

Paul Gauguin
(1848-1903)
Le Cheval blanc
1898

Canvas
140 × 91.5
Purchased in 1927
R.F. 2616

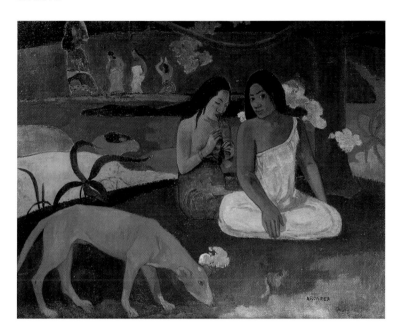

<<

Paul Gauguin
(1848-1903)
Portrait de l'artiste
1896

Canvas
40 × 32
Dedicated to *his friend Daniel*
Gift of Mme Huc
de Montfreid, 1951
Purchased in 1968
R.F. 1966-7

<

Paul Gauguin
(1848-1903)
L'Autoportrait
au Christ jaune
1890-1891

Canvas
38 × 46
Purchased with the help
of M. Philippe Meyer and
Japanese patronage coordinated
by the *Nikkei* newspaper,
and the assistance of the
Fonds du Patrimoine, 1994
R.F. 1994-2

∧

**Pierre Bonnard
(1867-1947)**
Femmes au jardin
Salon des Indépendants, 1891

Paper on canvas
each panel: 160 × 48
Donation in lieu of payment
of death duty, 1984
R.F. 1984-159 to 162

jaune, first entrusted to Daniel de Monfreid, was bought by Vollard in 1902, then by Maurice Denis who hung it in his dining-room at Saint-Germain-en-Laye in 1903 and never parted with it until his death. In it Gauguin depicted himself jauntily in front of his 1889 *Christ jaune* (Albright-Knox Art Gallery, Buffalo) and his ceramic self-portrait in the form of a grotesque head made in the winter of 1890-1892, a poignant testimony to his physical and psychological suffering in those particularly difficult years.

For today's visitors Sérusier's *Le Talisman* sheds light on the genesis of the nabi group in the autumn of 1888. Bonnard, Vuillard, Maurice Denis, Roussel and Ranson, fellow students at the studios of the Académie Julian or the École des Beaux-Arts, were before long joined by the Swiss painter Vallotton and the sculptor Maillol, who came from Banyuls. As "prophets" of a new art – *nabi* means "prophet" or "inspired" in both Hebrew and Arabic – they rejected all academicism and any notion of an official school. They absorbed the lessons of Gauguin for a new generation – they were all born between 1860 and 1870 – and wanted to go beyond mere easel painting and return to great decorative art, from Egyptian antiquity to Puvis de Chavannes. Carried along by the Art Nouveau trend which was at its height in the 1890s, they were profoundly influenced by *Japonisme*, a major movement that had swept European art since the opening up of Japan to western trade in 1853. Rejecting the traditional hierarchy of the major and the minor arts, the nabis practised all the varied techniques of the decorative arts and were heavily involved in the movement to renew print-making and poster illustration. They also collaborated with revolutionary figures in the theatre such as Paul Fort and Lugné-Poë through their stage sets, costumes and lithographed programmes for a new and radical theatre repertory.

The collection the Musée d'Orsay offers its visitors today is one of the richest in the world, thanks to gifts, bequests, acquisitions through donation in lieu of death duty and purchases, which have increased in number over the past fifteen years.

Bonnard, the "Japan-obsessed nabi", is especially well represented by works with a very Japanese influence, such as *Le Peignoir* and *Le Corsage à carreaux* (bought in 1939 and 1947 respectively), the four decorative panels of the *Femmes au jardin* (1891) from the former Florence

>
Pierre Bonnard
(1867-1947)
Crépuscule or
La partie de croquet
Salon des Indépendants,
1892

Canvas
130 × 162.5
Gift of Daniel Wildenstein
through the Association
of Friends of the Musée
d'Orsay, 1985
R.F. 1985-8

Gould collection, and the famous *Partie de croquet*, his nabi masterpiece painted in 1892 when the artist was only twenty-one years old, and given to the museum by Mr Daniel Wildenstein in 1985.

The four panels of *Femmes au jardin* were initially designed as a screen, but were separated by Bonnard himself when he exhibited them at the 1891 Salon des Indépendants. The following year at the same Salon he showed *Crépuscule* or *La Partie de croquet* which sums up his nabi experiments to perfection: renunciation of the traditional concept of space under the combined influence of Japonisme, Gauguin and work on stage sets; flat, sinuous figures; no modelling; decorative exuberance; and a composition based on contrasts of value. The same year Vuillard created a more ascetic version of the nabi principles in *Au lit*, with its *camaïeu* of flat tints following a subtle and spare geometric structure.

The important Vuillard bequest – including *Au lit*, a painting particularly characteristic of nabi aesthetics – entered the museum in 1941 to enhance a Vuillard collection that already included three panels from the

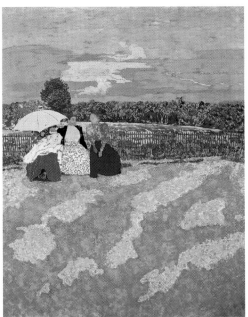

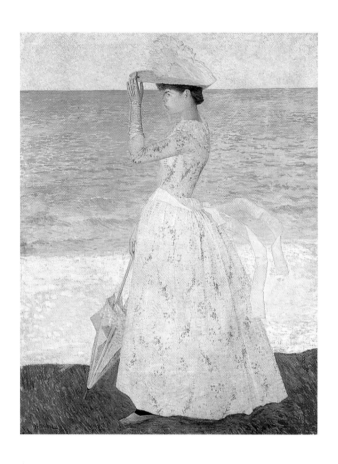

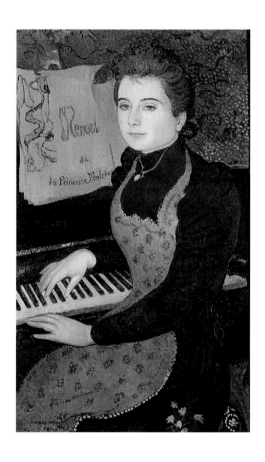

∧
Aristide Maillol
(1861-1944)
La Femme à l'ombrelle
c. 1890-1895

Canvas
190 × 149
Purchased in 1955
R.F. 1977-241

Jardins publics and the delightful picture entitled *Le Sommeil* from 1891.

In 1894 the "Zouave nabi" – Vuillard – produced one of his first decorative sequences for the private mansion of Alexandre Natanson. The Musée d'Orsay owns five of the nine panels executed using distemper. Their composition is based on the alternation of dark and light masses and a rhythmic linking underlined by the continuity of the sinuous lines. The influence of Puvis de Chavannes is perceptible, as it is in *Les Muses* by Maurice Denis, a panel painted in 1893, and *La Femme à l'ombrelle* by Maillol, where the decorative intention governs the internal economy of the painting.

<
**Maurice Denis
(1870-1943)**
*Le Menuet de la
princesse Maleine*
or *Marthe au piano*
1891

Canvas
95 × 60
Donation in lieu of payment
of death duty, 1999
R.F. 1999-3

>
**Maurice Denis
(1870-1943)**
Les Muses
Salon des Indépendants,
1893

Canvas
171.5 × 137.5
Purchased in 1932
R.F. 1977-139

In 1999 the ninth panel of Vuillard's Natanson decoration, *Les Premiers pas*, which had vanished from sight during the Second World War, was rediscovered by a Parisian gallery and it is currently on the international art market.

The works representing Maurice Denis, the youngest of the group nicknamed "the nabi of the beautiful icons", have also increased considerably in number over the past ten years. A 1999 acquisition through donation in lieu of death duty, *Le Menuet de la princesse Maleine,* painted in 1891, has added to the works depicting the artist's fiancée, then wife, Marthe Meurier, who already featured in several different poses in *Les Muses,* still the most

∧

Maurice Denis
(1870-1943)
Hommage à Cézanne
1900
Salon of the Société
Nationale des Beaux-Arts,
1901

Canvas
180 × 240
Gift of André Gide, 1928
R.F. 1977-137

∧

Félix Vallotton
(1865-1925)
Intérieur, femme en bleu
fouillant dans une armoire
1903

Canvas
81 × 46
Purchased thanks to
M. Philippe Meyer, 1997
R.F. 1997-4

>

Félix Vallotton
(1865-1925)
Le Ballon
1899

Cardboard on wood
48 × 61
Carle Dreyfus bequest, 1953
R.F. 1977-353

>>

Ker-Xavier Roussel
(1867-1944)
La Terrasse
c. 1892

Canvas
36 × 75
Purchased in 1992
R.F. 1992-1

∧

**Pierre Bonnard
(1867-1947)**
Intimité, Charles Terrasse,
the artist's brother-in law,
and his wife Andrée
1891

Canvas
28 × 36
Purchased with the assistance
of M. Philippe Meyer through
the Foundation for French
Museums, 1992
R.F. 1992-406

important painting in the museum's sequence. The "small format" room brings together an outstanding set of nabi works of modest dimensions, such as *Intimité* by Bonnard, *Taches de soleil* by Maurice Denis, *Crépuscule* by Vallotton, *La Terrasse* by Roussel and *Lustral* by Ranson.

Vallotton, nicknamed the "foreign nabi", is very well represented on the museum's walls by a series of works highlighting his originality within the movement: the Japanese-influenced space in *Le Ballon* and *La Troisième galerie au Théâtre du Châtelet*; the intimism of *La Partie de poker* and *Femme en bleu fouillant dans une armoire* (bought in 1997); the acidic, humorous realism of *Dîner effet de lampe;* and *Portrait de Gabrielle Bernheim*, the artist's wife.

Finally *Hommage à Cézanne* by Maurice Denis assembles his fellow artists in Ambroise Vollard's gallery around a *Nature morte* by Cézanne; from left to right they are Odilon Redon, Vuillard, the critic André Mellerio, Ambroise Vollard, Maurice Denis, Sérusier, Ranson, Roussel, Bonnard and the artist's wife Marthe. Homage to Cézanne, but to Redon and Gauguin too: one of Gauguin's paintings can be discerned in the background, and he was unanimously admired by the nabis.

This picture depicting the whole group life-size was painted in 1900, the date of their last joint exhibition before the various followers of the nabi movement separated to make their own way in the 20th century.

Naturalism
and symbolism

For a long time the artists who did not fit into the Impressionist line of descent were neglected. They have now been restored to a place of honour at the Musée d'Orsay. The paintings purchased during their lifetime have been brought out from the reserve stock, and new purchases are making it possible to appreciate the diversity of foreign schools.

∧
**Ernest Meissonier
(1815-1891)**
*Le Siège de Paris
(1870-1871), Allégorie*
1870 and 1884

Canvas
53.5 × 70.5
Bequest of Mme Meissonier,
the artist's widow, 1898
R.F. 1249

<
**Gustave Doré
(1832-1883)**
L'Énigme
1871

Canvas
130 × 195.5
Purchased in 1982
R.F. 1982-68

The events that marked the fall of the Second Empire, the war of 1870, the siege of Paris and the Commune, were in no way reflected in the collections of the Musée du Luxembourg. Indeed, everything happened so suddenly that few artists had time to be greatly inspired. Nonetheless, Gustave Doré, who remained in Paris, witnessed scenes which prompted some extraordinary drawings from life, along with several allegorical paintings; these included *L'Enigme,* acquired recently by the Musée d'Orsay. At the posthumous sale of Doré's work in 1885, this painting was grouped with *L'Aigle noir de Prusse* and *La Défense de Paris* in a sequence entitled *Souvenir de 1870.* Two lines written by Victor Hugo in 1837 were associated with *L'Enigme*:

"O spectacle, ainsi meurt ce que les peuples font !
Qu'un tel passé pour l'âme est un gouffre profond."

Backed by a blazing city – Paris, without a doubt – the civilian and military victims of the conflict surround the weeping image of France, personified by a winged woman who interrogates a sphinx as to the reasons for the disaster.

A large number of Meissonier sketches entered the Musée du Luxembourg from an 1898 bequest by the artist's widow and an earlier gift from his son Charles; among them was an impressive study for *Le Siège de Paris.* This painting was feverishly executed in Meissonier's Poissy studio, in the heat of his rage at France's defeat; his Paris house had been requisitioned by the enemy. "That

>
**Paul-Joseph Blanc
(1846-1904)**
*Le Vœu de Clovis à la bataille
de Tolbiac; Le Baptême de Clovis*
In the upper part, *La Glorification de
Clovis* and *Grégoire de Tours écrivant
son "Histoire des Francs"*, maquette
for the decorative programme for
the Panthéon
1875
1876 Salon

Canvas
110 × 160
Purchased in 1998
R.F. 1998-38

>
**Jean-Paul Laurens
(1838-1921)**
*L'Excommunication de
Robert-le-Pieux, en 998*
1875 Salon

Canvas
130 × 218
Purchased in 1875
R.F. 151

was my vengeance", Meissonier wrote later in his *Entretiens*. One of the identifiable figures in the picture is the painter Regnault, who is seen collapsing beside a monumental image representing the city of Paris, which stands before the national flag draped in a lionskin. This giantess makes the whole painting into an allegory: without her, it would consist of nothing other than war images such as were produced in vast numbers after 1880 by chroniclers of military life like Edward Detaille.

Meissonier, who was basically a specialist in smaller formats, dreamed of developing this sketch into a full-blown painting, but never did so; likewise, he died before completing the state commission for the Panthéon. In 1874 Philippe de Chennevières, the new director of the Beaux-Arts, called on a whole series of artists, Puvis de Chavannes in particular, for this huge patriotic programme; Puvis first painted *L'Enfance de sainte Geneviève*, then from 1893 took over the painting commissioned without success from Meissonier.

The youngest artist to be chosen was Joseph Blanc, awarded the Prix de Rome in 1867, who was less than thirty years old. At the 1876 Salon he showed the finished sketch for *Histoire de Clovis* which turned up just at the right time to round off a series of maquettes for the decoration of the Panthéon, including those by Puvis for the *Ravitaillement de Paris* and by Jean-Paul Laurens for *Les Derniers moments de sainte Geneviève*.

The Third Republic founded after the defeat of the Commune in 1871 wanted to make its presence felt in the artistic field, and a painter like Jean-Paul Laurens, a convinced atheist and humanist, contributed to this by depicting deliberately anti-clerical medieval subjects. In *L'Excommunication de Robert-le-Pieux*, exhibited at the 1875 Salon, he condemned the fanaticism of the church. Robert II known as the Pious, the son of Hugues Capet, had married Berthe de Bourgogne despite the fact that he was the godfather of one of her children from her first marriage. For Pope Gregory V those links made the marriage incestuous, so he excommunicated the king until he repudiated the queen. The artist skilfully uses the perspective of the throne room to isolate the condemned couple in a dramatic fashion, while a snuffed-out candle lies thrown on the floor and the prelates leave through the Romanesque doorway.

After the havoc caused by the fires of the Commune, there was an increasing number of programmes for large decorative schemes, not only in public buildings but in private townhouses as well. Few of these private commissions have been preserved: the recent rescue of Luc-Olivier Merson's decoration for the Hôtel Watel-Dehaynin is an exception. Unlike the city of Paris, which kept the award-winning sketches for all the competitions it organized for local town halls or the Hôtel de Ville, the state let the artists keep their sketches. While the plaster maquette of the ceiling of the Comédie-Française, entrusted to Albert Besnard to ascertain the shape of the painted canvases for a commission, was preserved and could be recovered from the former premises of the Beaux-Arts administration in 1980, we are indebted to a recent chance acquisition for the first sketch by Benjamin Constant for the ceiling of the Opéra-Comique. There was even a plan to decorate Paris' railway stations; it was an old, unrealized dream of Courbet's to contribute to such a project. In 1900, the more academic artists (Gabriel Ferrier, Benjamin Constant and Pierre Fritel) took part in the

v
Luc-Olivier Merson
(1846-1920)
La Vérité
Decoration for the staircase
of the Hôtel Watel-Dehaynin
1901

Canvas
221 × 372
Purchased when the house
was demolished, 1974
R.F. 1974-27

v
v
Benjamin-Constant
(1845-1902)
Glorification de la musique
Initial sketch for the ceiling of
the auditorium of the Opéra-
Comique in Paris, painted in
1898

Paper on cardboard
diameter: 56
Purchased in 1979
R.F. 1979-62

∧
Fernand Cormon
(1845-1924)
Caïn
1880 Salon

Canvas
380 × 700
Purchased in 1880
R.F. 280

>
Antonio Mancini
(1852-1930)
Pauvre écolier
1876 Salon

Canvas
130 × 97
Gift of Charles Landelle, 1906
R.F. 1980-135

decoration of the Hôtel Terminus beside the Gare d'Orsay, while Fernand Cormon painted landscapes for the main hall of the station.

One of these may still be seen behind another of Cormon's compositions, one of the glories of the last official Salon in 1880 which was immediately acquired for the Musée du Luxembourg: *Caïn*, the first "prehistoric" subject ever tackled by the artist. In fact, this monumental work refers to some verses of "La conscience", from *La Légende des siècles* by Victor Hugo, who had been forced into exile by the man he had christened *Napoléon le Petit* but had now returned in triumph to republican France. Cormon has used the traditional procedures of academic art in *Caïn*; indeed, his contemporaries took a delight in identifying certain professional models in the painting's hairy fugitives. Nonetheless, it is clear that he has already assimilated certain characteristics of naturalist painting, which at that time were dominant, along with every possible variation of the official art of 1880, at the beginning of the Third Republic. Those who had been ill-treated under the Second Empire were now much glorified (though some, of course, were dead). The prices of Millet's paintings rose sharply; the École des Beaux-Arts organized

^
**Jules Bastien-Lepage
(1848-1884)**
Les Foins
1877
1878 Salon

Canvas
180 × 195
Purchased in 1885
R.F. 2748

a Courbet exhibition in 1882 and a Manet exhibition in 1883; Jules Bastien-Lepage, who died aged 36 in 1884, was given a retrospective of his work a few months later at the Hôtel de Chimay, at which the administration chose to buy the large painting *Les Foins* for the Musée du Luxembourg. This purchase added a naturalist work with life-size figures to the collection, providing a link both in scale and subject matter with the proclamation paintings of 1849-1850. With its light colours and rapidly applied brushstrokes, the painting also bore a certain similarity to the Impressionist technique, following in the wake of Manet.

Bastien-Lepage, a pupil of Cabanel at the École des Beaux-Arts, had narrowly missed winning the Prix de Rome. He then decided to devote himself to painting the peasants of his native village, Damvilliers in Lorraine, as in the previous generation Courbet had chosen to glorify Ornans in Franche-Comté, and Jules Breton Courrières in Artois. *Les Foins* exhibited at the 1878 Salon is the first demonstration of this. The feeling of open air and space that emanated from this work caught the public's attention, but it was ignored by officialdom until the artist became the leader of the naturalists in the 1880s. Bastien-Lepage had a great influence, particularly on the foreign artists living in Paris and

London, which he visited. His style spread across Europe and America and even as far as Australia.

Naturalist painting as a genre was especially attached to rustic themes (another famous example is Léon Lhermitte's *La Paye des moissonneurs*) and the world of modern industry (as in Cormon's *La Forge* and *Au pays noir* by the Belgian painter Constantin Meunier, both produced at the turn of the century). Yet no sooner was naturalism established in the full glare of official approval, than it began to be questioned by those who, like Joséphin Péladan, the future manager of the Salon de la Rose † Croix, saw it as a symbol of decadence in art caused by a lack of idealism and spirituality. Vulgarized naturalism, with its quickly applied colours, began to be perceived as an easy way of painting. It was used for every theme, including those of religion and symbolism, and soon invaded every country in Europe, most of which had less suffocating academic structures than France. The stronger artistic personalities adopted a fine and vigorous brand of naturalism, like the Dutch painter Breitner (represented at the Musée d'Orsay by a recent purchase), or the German, Liebermann. Between 1870 and 1880 the latter artist painted a large number of subjects drawn from the working world, probably even more than his French counterparts; and there is little doubt that he visited Paris and perhaps Barbizon during this period. Liebermann also had the remarkable example of painters such as Menzel, who unfortunately for us belonged to a generation too old to have been

represented in the Luxembourg, despite the presence of his striking *Rolling Mill* at the 1878 Universal Exhibition. Later, in 1895, when the Musée du Luxembourg was finally taking an interest in foreign artists, Liebermann's *Biergasten at Brannenburg* (1893) was acquired. Here, the theme is somewhat more pleasant. The canvas is bright and clear, with special attention given to atmospheric and light effects; hence the work seems more post-Impressionist than naturalist, as naturalist paintings often tend to be swamped in an unvarying, leaden light.

>
Max Liebermann
(1847-1935)
Brasserie de campagne
à Brannenburg, Bavaria
1893
Salon of the Société
Nationale des Beaux-Arts,
1894

Canvas, 70 × 100
Purchased in 1894
R.F. 1977-227

>
Hans Thoma
(1829-1924)
Siesta
1889

Canvas, 88 × 117
Gift of the Association
of Friends of the Musée
d'Orsay, 1989
R.F. 1989-39

>
Elie Delaunay (1828-1891)
Madame Georges Bizet, née
Geneviève Halévy, subsequently
Mme Émile Straus
1878 Salon

Canvas
104 × 75
Bequest of Mme Émile Straus, with
reservation of lifetime use on behalf
of her husband, 1927; entered
collection in 1929
R.F. 2642

v
**Albert Besnard
(1849-1934)**
*Portrait de Madame
Roger Jourdain*
Salon des Artistes Français, 1886

Canvas
200 × 153
Gift of Mme Roger
Jourdain, 1921
R.F. 2302

∧∧
**Léon Bonnat
(1833-1922)**
Madame Pasca
1874
1875 Salon

Canvas
222.5 × 132
Purchased from the bequest
of Arthur Pernolet, 1915
R.F. 2245

The sphere of portraiture shows clearly how techniques evolved, from the sombre, serious likenesses of Bonnat and Delaunay to the brilliant work of Sargent. For instance, Sargent's *Édouard Pailleron* (1879) is executed with daring freedom, while Albert Besnard's *Portrait de Madame Roger Jourdain* makes full and fresh use of artificial light. The technique of Boldini, an expert exponent of society paintings deftly executed with virtuoso skill, can be seen in his portrait of Robert de Montesquiou. Jacques Émile Blanche often made

<
**Jacques-Émile Blanche
(1861-1942)**
*Portrait de Marcel Proust
(1871-1922)*
1892

Canvas
73.5 × 60.6
Donation in lieu of payment
of death duty, 1989
R.F. 1989-4

v
**Giovanni Boldini
(1842-1931)**
*Le Comte Robert de Montesquiou
(1855-1921)*
Salon of the Société Nationale
des Beaux-Arts, 1897

Canvas
160 × 82.5
Gift of Henri Pinard in the name
of Comte de Montesquiou, 1922
R.F.1977-56

quick sketches to capture the personality of his models. But his famous 1892 *Portrait de Marcel Proust* with an orchid in his buttonhole is still in the classical tradition. What was required was a full-length portrait in the tradition of Whistler, Manet or Sargent, but the painter was dissatisfied with the result and cut it down later. The truncated version remained in Marcel Proust's drawing-room, with reproductions spreading its fame after 1920. It is now one of the icons of 20th-century literature.

^ ^
**Valentin
Alexandrovitch Serov
(1865-1911)**
*Madame Lwoff
(1864-1955)*
1898

Canvas
90 × 59
Donation from Prince André
Lwoff and M. Stéphane Lwoff,
the model's sons, 1980
R.F. 1980-8

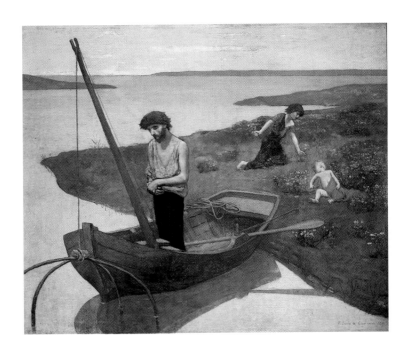

**Pierre Puvis
de Chavannes
(1824-1898)**
*Les Jeunes Filles au bord de
la mer.* Decorative panel
1879 Salon

Canvas
205 × 154
Gift of Robert Gérard, 1970
R.F. 1970-34

>

**Pierre Puvis
de Chavannes
(1824-1898)**
Le Pauvre Pêcheur
1881 Salon

Canvas
155.5 × 192.5
Purchased in 1887
R.F. 506

Most portraits tended to remain in the family of the person who commissioned them, only reaching museums many years later, usually in the form of a donation. This was the case of a portrait by the Russian painter Serov, *Madame Lwoff,* most delicately executed in nabi tones. When the move towards symbolism became established as a reaction against naturalism – Jean Moréas's *Manifeste du symbolisme* dates from 1886 – two artists became figureheads for the younger generations: Puvis de Chavannes and Gustave Moreau.

The former, famous for his large decorative paintings at the Panthéon and the museum at Amiens, did not turn his back on easel painting, exhibiting *Les Jeunes Filles au bord de la mer* at the 1879 Salon. This triadic composition can be seen as a depiction of the same woman from three different points of view – full-face, from behind and in profile – or at different ages in her life. Some see it as foreshadowing an intellectual view of time and space which heralds the distortions of Cubism. *Le Pauvre Pêcheur* from the 1881 Salon, shown again several times in the course of the following years and very much admired by younger artists, was bought for the Musée du Luxembourg at the one-man show of Puvis's work at the Durand-Ruel gallery in 1887. In it the artist gives a poignant view of poverty, with all the elements in the composition, including the slant of the mast to the left, contributing towards it. Before long the use of large simplified flat tint areas had a profound impact on Gauguin, who claimed he wanted to do "Puvis in colour".

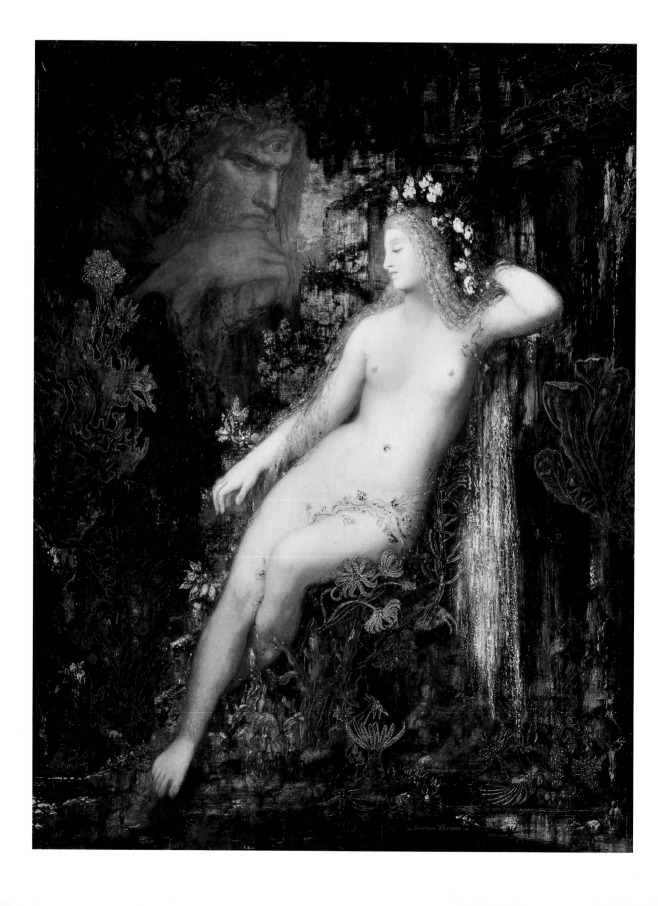

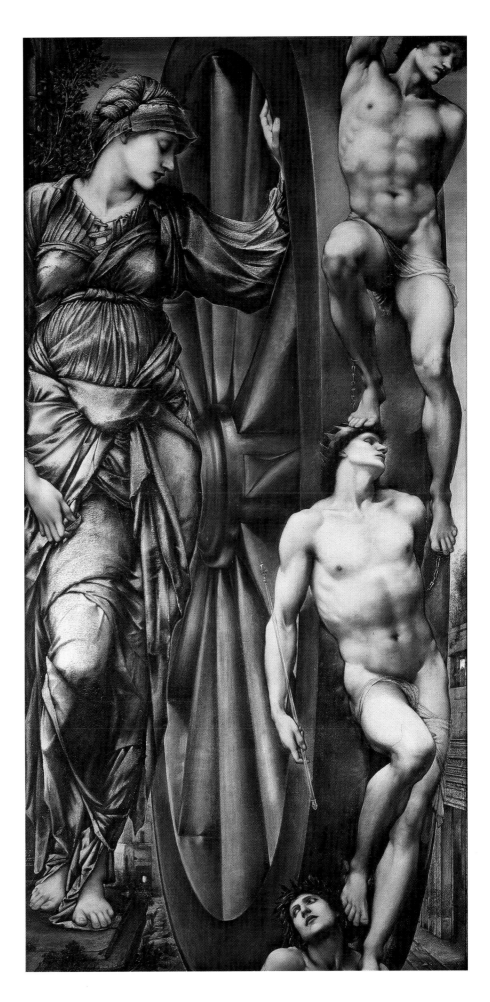

<
**Gustave Moreau
(1826-1898)**
Galatée
1880 Salon

Wood
85.6 × 66
Purchased with the help of
the Meyer foundation and
Japanese patronage coordinated
by the *Nikkei* newspaper
and the assistance of the
Fonds du Patrimoine, 1997
R.F. 1997-16

>
**Sir Edward Burne-Jones
(1833-1898)**
The Wheel of Fortune
1877-1883

Canvas
200 × 100
Purchased in 1980
R.F. 1980-3

Gustave Moreau, a close friend of Puvis, has a very different technique; in his finished compositions he piles up innumerable carefully documented details, assembling them to form a very personal phantasmagoria, like the little female figures, animals and marine plants in the famous painting *Galatée* recently acquired for the Musée d'Orsay. Joris-Karl Huysmans gave a very enthusiastic description of this work in his criticism of the 1880 Salon, praising "the magical effects produced by this visionary's brush" and describing the sea cave where Galatea rests, oblivious of the love the Cyclops Polyphemus, as a "haunt lit up with precious stones like a tabernacle and containing the inimitable, radiant jewel, the white body tinged with pink on the breasts and lips of Galatea asleep amidst her long fair tresses!"

Another precursor of symbolism was the English Pre-Raphaelite painter Burne-Jones, long poorly represented in French collections. The purchase of *The Wheel of Fortune* in 1980 has helped to fill that gap. This is a large painting steeped in recollections of Italian painting – particularly Michelangelo – where the artist plays with the disproportion between the tall figure of Fortune and the smaller figures of the men she raises to crush beneath her

V
Arnold Böcklin
(1827-1901)
La Chasse de Diane
1896

Canvas
100 × 200
Purchased in 1977
R.F. 1977-1

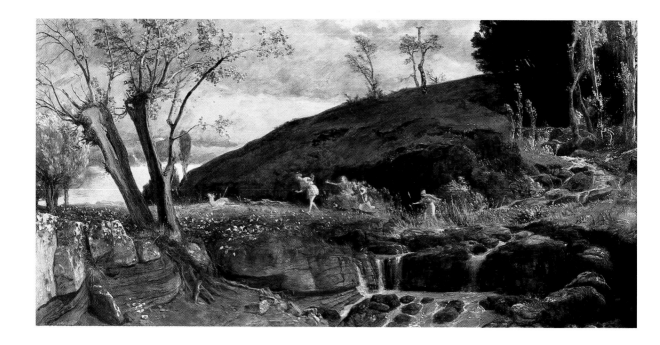

<
**Franz von Stuck
(1863-1928)**
La Chasse sauvage
1899

Canvas
97 × 67
Purchased in 1980
R.F. 1980-7

∨
**James Ensor
(1860-1949)**
La Dame en détresse
1882

Canvas
100.4 × 79.7
Gift of Armilde
Lheureux, 1932
R.F. 1977-165

wheel. Puvis de Chavannes had hoped to exhibit this already famous picture at the Salon de la Société Nationale des Beaux-Arts, the new Salon created in 1890 of which he became president in 1891 on the death of Meissonier. But in the end Burne-Jones sent only drawings.

In 1977 when the Musée d'Orsay project was taking shape the Louvre managed to buy a late work by the Swiss painter Böcklin, *La Chasse de Diane*, still Romantic in spirit in the importance it accords to the landscape, which echoes Paul Huet's *Le Gouffre*. *La Chasse sauvage* by the German artist Stuck, a member of the next generation but still deeply imbued with antique culture, is very different, with its choice of a close-up view of the protagonists in the drama. For a long time this picture belonged to the collections of the Carnegie Institute in Pittsburg, which disposed of it in 1979.

∧
**Eugène Carrière
(1849-1906)**
L'Enfant au verre
1885

Canvas
61 × 51
Louis-Henri Devillez
donation, 1930
R.F. 3106

∨
**Fernand Khnopff
(1858-1921)**
Marie Monnom, daughter of the
Brussels publisher, subsequently
Mme Théo van Rysselberghe
1887

Canvas
49.5 × 50
Purchased in 1981
R.F. 1982-10

>
**George-Hendrik Breitner
(1857-1923)**
Clair de lune
c. 1887-1888

Canvas
70 × 101
Purchased in 1989
R.F. 1989-37

<
**Eugène Carrière
(1849-1906)**
Paul Verlaine (1844-1896)
1890
Salon of the Société Nationale
des Beaux-Arts, 1891

Canvas
61 × 51
Purchased with the participation
of the Association of Friends of
the Musée du Luxembourg, 1910
R.F. 3750

>
**Winslow Homer
(1836-1910)**
Summer Night
1890

Canvas
76.7 × 102
Purchased in 1900
R.F. 1977-427

Among the first subtly symbolist works to enter the Luxembourg was a delicate portrait of *Thadée Jacquet* by Aman-Jean, one of a group devoted to the Salon de la Rose † Croix and the new Société Nationale des Beaux-Arts. Also acquired were works by Eugène Carrière, whose immense *Famille du peintre* was brought in 1897. More to the modern taste, perhaps, are his attractive *L'Enfant au verre,* and his portraits of writers, especially his famous rendering of the poet Paul Verlaine, acquired in 1910 with the help of the Société des Amis du Luxembourg. It is essentially thanks to various donations (of which the most important were those of Carrière's friend the sculptor Devillez, in 1930, and the recent bequest of his son-in-law, Ivan Loiseau) that this artist is so well represented in the Musée d'Orsay. Nevertheless, Carrière remains a little-known figure in fin de siecle symbolism. In confining himself more and more strictly to a range of browns in the 1880s, he drew away from Ribot's brand of realism to arrive at a simple play of curves controlling a few light-filled zones. This produced a kind of dreamy magic, both in the intimist scenes where the artist relates, without anecdote, certain essential aspects of life, and in his sinuous, almost Art Nouveau landscapes.

<
**Charles Cottet
(1863-1925)**
*Rayons du soir,
port de Camaret*
1892
Salon of the Société
Nationale des Beaux-Arts,
1893

Canvas
74 × 110
Purchased in 1893
R.F. 847

v
**Giuseppe Pelizza
da Volpedo
(1868-1907)**
Fleur brisée
1896-1902

Canvas
79.5 × 107
Purchased in 1910
R.F. 1977-281

Most of the symbolists of the 1890 vintage gradually moved away from their early naturalism. This shift was especially notable in the case of Léon Frédéric, one of the few foreigners of that generation to be represented at the Musée du Luxembourg by several works, among them two important symbolist triptychs (one purchased, the other donated). Frédéric had the liking and support of Léonce Bénédite, the energetic curator of the Musée du Luxembourg. Bénédite was also a keen advocate of Charles Cottet, an austere but powerful painter who had trained at the Académie Julian and then with Alfred Roll. He had listened to Puvis de Chavannes's advice, but preferred a dark, austere, solid manner reminiscent of Courbet. One of his first distinctive works, *Rayons du soir*, painted when he was 29 years old, was purchased by the state at the 1893 Salon. In this peaceful scene painted at dusk, the human figure is reduced to a few silhouettes. It is evocative of the harsh life of the Breton fishermen in the Camaret district which Cottet discovered in 1886, often returning there with his friends from the *Bande noire*. Although Cottet exhibited his work at Le Barc de

^
**Angelo Morbelli
(1853-1919)**
*Jour de fête à l'hospice
Trivulzio à Milan*
1892

Canvas
78 × 122
Purchased in 1900
R.F. 1193

Boutteville alongside the nabis, these young artists were not yet attracting attention. Seurat, who died in 1891, would remain conspicuously absent for a long time to come; by contrast, his imitators of the Italian divisionist school were well represented after 1910 thanks to a series of fruitful contacts with the organizers of the Venice Biennale. But 1910 was too late for Segantini, who died on the eve of the 1900 Universal Exhibition, in which many of his works were prominently featured.

Bénédite and the administration were not really interested in avant-garde movements and it is only through recent purchases that the 1890s' fashion for compositions dominated by the colour blue is now represented.

<
Eugène Jansson
(1862-1915)
Logement prolétaire
1898

Canvas
115 × 80
Gift of David Allen Devrishian
in memory of his brother, 2000
R.F. 2000-1

∧
Léon Frédéric
(1856-1940)
Les Âges de l'ouvrier,
triptych
1895-1897
Salon of the Société Nationale
des Beaux-Arts, 1898

Canvas
163 × 187 (central section)
163 × 94 (side panels)
Purchased in 1898
R.F. 1152

∨
Alphonse Osbert
(1857-1939)
Les Chants de la nuit
Salon of the Société
Nationale des Beaux-Arts
1896

Canvas
77 × 124
Bequest of Yolande Osbert,
the artist's daughter, 1990
R.F. 1992-48

Until 1904 the Swedish painter Eugène Jansson made a speciality of these in his nocturnal views of Stockholm, deriving an expressive value from the lights of the city, as in *Logement prolétaire*.

Alphonse Osbert, a "painter of the soul" and a faithful follower of the Salons de la Rose † Croix organized between 1892 and 1897 by Joséphin Péladan, has a more idealistic cast of mind: he paints undergrowth beside calm lakes where female figures in timeless drapery frolic, in the manner of Puvis de Chavannes. He exhibited his first nocturnal picture *Les Chants de la nuit* at the Société Nationale des Beaux-Arts in 1896, then at the last Salon de la Rose † Croix in 1897; in it the intense yellow of the rising moon is the only contrast with a range of deep blues.

The tormented decorative art of Georges de Feure is in sharp contrast to this silent serenity; he too was a

∧

**Georges de Feure
(1868-1943)**
L'Abîme
1893-1894

Wood
44 × 59.5
Gift of Robert
Tchoudoujney, 1997
R.F. 1997-11

>

**Jan Toorop
(1858-1928)**
*Le Désir et
l'Assouvissement*
or *L'Apaisement*
1893

Pastel on beige paper
glued on to cardboard
76 × 90
Purchased in 1976
RF 36166

supporter of the Rose † Croix, though he only exhibited with them twice before playing a major role in the development of Art Nouveau. He showed *L'Abîme* inspired by Baudelaire in 1894. At night before the outline of a sleeping town three figures can be discerned. A winged succubus, a real demon of evil, watches over the sleep of a pious woman lying in the centre on the flower-strewn lawn and dressed as a countrywoman with a cross round her neck. She is dreaming of a naked woman, Eve as a true temptress, an image of the vice promoted by large cities.

The members of the group Les Vingt (Les XX), who had welcomed Seurat and Gauguin in Brussels and evolved into the Libre Esthétique movement, were undoubtedly regarded as overly heretical at the time. Two of them, the Belgian painter Khnopff and the Dutch artist Toorop, are at last represented thanks to recent purchases, Toorop by a work with a strange graphic effect which he gave to Maurice Denis in exchange for one of the latter's paintings. Like de Feure, Toorop depicts Christ's cross with the complementary and contradictory aspects of human nature – desire and satisfaction.

<
**Lucien Lévy-Dhurmer
(1865-1953)**
La Femme à la médaille
or *Mystère*
1896

Pastel
35 × 54
Gift of M. and Mme
Zagorowsksy, 1972
RF 35501

In the eruption of artistic changes that marked the close of the century, however wide the Luxembourg opened its doors it could never be more than the privileged instrument of official art. We learn much from its choices about the relationship between art and the administration around 1900. It has been the role of more recent acquisitions and donations (enabling the Musée d'Orsay to offer a brilliant selection of works by artists such as Levy-Dhurmer of Mucha, who were not unsuccessful at the time) to complete and vary the Luxembourg's narrower representation.

v
**Piet Mondrian
(1872-1944)**
*Départ pour la pêche
(Zuidersee)*
c. 1898-1900

Water-colour and charcoal
62 × 100
Purchased in 1987
RF 41384

After 1900

The 1900 Universal Exhibition marked the triumph of Art Nouveau. A new century was opening, rich in pictorial developments. Abroad, the Viennese Secession and the Glasgow school were bubbling with new ideas, while in France painters were rediscovering space and colour.

<
Pierre Bonnard
(1867-1947)
En barque
c. 1907

Canvas
278 × 301
Purchased in 1946
R.F. 1977-73

>
Ker-Xavier Roussel
(1867-1944)
Polyphème, Acis
et Galatée
Decorative work
for Lugné-Poé
c. 1910

Paper on canvas
273 × 165
Purchased in 1943
R.F. 1977-304

At the turn of the century, the nabi movement began to lose cohesion, having in many ways foreshadowed the decorative exuberance of Art Nouveau. While we cannot really call this a rupture, since nabi was never more than a loose brotherhood of painters held together by friendship, nonetheless from 1900 onwards those painters increasingly went their own ways; in doing so, they were fortified by over a decade of shared experience and endorsed by various group exhibitions in galleries (such as Le Barc de Boutteville), in the premises of the *Revue Blanche,* or at the house of the great dealer Siegfried Bing. The last nabi exhibitions as such were held in 1900 and 1902 at the Galerie Bernheim-jeune; after that, Vuillard and Bonnard continued to exhibit there, but in an individual capacity. Vallotton returned to his country of origin, Switzerland, where he produced realistic, daringly-coloured paintings with a pronounced taste (acquired during his nabi years) for disconcerting perspectives and arrangements. Also around 1900, Maillol, who for a time had flirted with the nabis, finally abandoned painting to devote himself to sculpture in which he sought a new classicism in the shapes of his powerfully-built female nudes.

Bonnard, Vuillard, Maurice Denis and Roussel went on to pursue brilliant individual careers, and despite their stylistic differences we find them sharing the common ground of large-scale decorative painting and intimist scenes. From their nabi years, all four retained a taste for large decorated surfaces and the Musée d'Orsay is

fortunate to possess several important works by Denis, Vuillard and Roussel. The most notable are eight paintings completed by Denis between 1898 and 1900 for the chapel of the Collège Sainte-Croix at Le Vesinet, which were transferred to Orsay from the Musée des Arts Décoratifs; these enable us to appreciate the religious inspiration of this profoundly Christian artist. After the deconsecration of the chapel after 1905 because of the new laws affecting religious gatherings, the ensemble (which was remounted on canvas) was placed in reserve and successfully restored later.

Vuillard, on the other hand, was more interested by interior decoration. After completing a series of panels for the writer Claude Anet in 1902, he went on to execute another sequence for Henry Bernstein in 1908 which is rather more realistically treated than his first nabi ensembles. In 1911, he painted *La Bibliothèque* for the office of the Princesse de Bassiano; here, a large-scale format is used to project an intimate, balanced and wonderfully harmonious scene (crowned by a frieze) in which a classical tapestry serves as a backdrop. Two years later, Vuillard was commissioned to decorate Bois Lurette, the Bernheim-jeune villa at Villers-sur-Mer, with a series of panels; the Musée d'Orsay possesses one of these, *Femmes sous la véranda,* thanks to the generosity of the descendants of the Bernheim-jeune family.

Ker-Xavier Roussel looked to mythology for subject matter when he painted his highly animated and colourful larger compositions, *L'Enlèvement des filles de Leucippe* and *Polyphème, Acis et Galatée.* The latter is a huge panel commissioned by the theatre director Lugné-Poë, with whom the nabis had collaborated from the very beginning. In 1913, the art patron Gabriel Thomas organized three former nabis to decorate the new Théâtre des Champs-Elysées, then under construction by the Perret brothers. The dome was entrusted to Maurice Denis; he covered it with classical themes evoking music and opera, in the bland colours which he was to use thereafter for all his larger decorative works. The Musée

> **Maurice Denis**
(1870-1943)
Maquette for the cupola of the Théâtre des Champs-Élysées
1911-1912

Distemper on reinforced plaster, unpolished tinted and tracked glass; diameter: 240
Purchased in 1983
R.F. 1983-89

v
Édouard Vuillard
(1868-1940)
La Bibliothèque
Decorative work for Princess Brassiano
1911

Canvas
400 × 300
Purchased in 1935
R.F. 1977-368

d'Orsay possesses the reduced maquette of this dome, miraculously preserved because it had remained in the Thomas family's house at Meudon until 1983. The bas-reliefs of the theatre were done by the sculptor Bourdelle, Vuillard decorated the foyer, and Roussel covered the curtain with a bacchanalian scene contiguous to another at the nearby Comédie des Champs-Elysées. All these works were decorative schemes intended for public buildings or arising from private commissions, and show a clear swing back to classicism, a pronounced trend in the first decade of the 20th century.

**Pierre Bonnard
(1867-1947)**
L'Après-midi bourgeoise
1900

Canvas
139 × 212
Donation in lieu of payment
of death duty, 1987
R.F. 1988-50

**Pierre Bonnard
(1867-1947)**
La Loge
1908

Canvas
91 × 120
Donation in lieu of payment
of death duty, 1989
R.F. 1989-32

**Édouard Vuillard
(1868-1940)**
*La Chapelle du château
de Versailles*
1917-1919

Paper on canvas
96 × 66
Jacques Laroche donation
with reservation of lifetime
use, 1947; entered collection
in 1976
R.F. 1947-33

Bonnard continued in his own way, remaining the most deliberately innovative of the ex-nabis and frequently anticipating the pictorial audacities of the later 20th century. While voluntarily holding aloof from the various great trends of fauvism, cubism and abstract art, Bonnard, who had never been a theorist, became completely involved in his investigation of colour and the spatial possibilities of painting. Thus most of his work after 1905 has gone to the Musée National d'Art Moderne in the Centre Georges Pompidou, although the Musée d'Orsay can still exhibit some canvases, notably *En barque,* which show Bonnard's contribution to the crucial first years of the 20th century.

Following in the wake of Renoir and Mary Cassatt, Bonnard tackled a subject that is especially evocative of Parisian life, the box at the theatre, in his portrait of the Bernheim-Jeune brothers and their wives. The unusual framing and the impression of polite boredom that emanates from the spectators captured as they go through a society ritual demonstrate the brilliance with which Bonnard managed to turn a commissioned work into a piece of pure painting, tinged with subtle humour.

It is easy to discern the parting of ways between Vuillard and Bonnard in the field of portraiture, which remained a predilection for the former nabis. Vuillard's portraits are warmly intimist in flavour and treated with a new respect for classical perspectives and his habitual sensitivity to atmosphere. This is particularly evident in *La Chapelle de Versailles* and in the important series of portraits by Vuillard at Orsay, such as those of the writer *Romain Coolus, La Princesse de Polignac* and *Mme Bénard.* Bonnard's technique is completely différent, while remaining consistent with his nabi innovations. *La Femme au chat* (1912) and the extraordinary *Portrait des frères Bernheim* (1920), now lodged at the Centre Georges Pompidou, show his exploration of visual fields and his attempt to render their totality by the use of new effects in perspective. Bonnard's *Nature morte, assiette de pommes,* from the former Gould collection, was recently acquired for the Musée d'Orsay by donation in lieu of death duty and gives evidence of spatial experiments similar to those of *La Femme au chat*, which dates from about the same period. The last painting by Bonnard, a recent purchase from 1996, is

Jeux d'eau or Le Voyage (c. 1906-1910), one of the four decorative panels he made for the dining room of the private house of Misia Sert (formerly Misia Natanson) on the Quai Voltaire in Paris. It is a very colourful and inventive decorative symphony where the artist gives free rein to his creative imagination in a work that stands out like a wonderful scene from an opera.

Both in France and abroad, the 20th century began in a ferment of new artistic movements, mostly dominated by research into the nature of colour. 1904 and 1905 emerge as key years just prior to the explosion of fauvism, foreshadowed by Van Gogh, Gauguin and the Impressionists. The autonomy of colour and its relationship with form is the central concern of a painting by Matisse, *Luxe, calme et volupté* (1904), which the Musée d'Orsay acquired by donation in lieu of death duty in 1982. This painting, with its Impressionist roots, preceded *Le Luxe I* which in turn paved the way for Matisse's great *La Musique* and *La Danse* commissioned

∧
Pierre Bonnard
(1867-1947)
Jeux d'eau or *Le Voyage*
Salon d'Automne, 1910

Canvas
230 × 300
Purchased with the assistance of
the Fonds du Patrimoine, 1996
R.F. 1996-18

>
André Derain
(1880-1954)
Pont de Charing Cross
1906

Canvas
81 × 100
Max and Rosy Kaganovitch
donation, 1973
R.F. 1973-16

**Henri Matisse
(1869-1954)**
Luxe, calme et volupté
1904

Canvas
98.5 × 118.5
Donation in lieu of payment of death
duty, 1982; deposited by the Musée
National d'Art Moderne, 1985
DO 1985-1

in 1909 by the Russian collector Stchoukine (Saint Petersburg, Hermitage Museum). *Luxe, calme et volupté,* which Matisse painted when staying in Saint-Tropez with his friend Signac in 1904, clearly demonstrates the transition from neo-Impressionism to fauvism. It illustrates the precise moment when the theoretical research underlying divisionism tipped over into exaltation of the power of pure colour, in particular under the pressure of the conflict experienced and expressed by the artist himself between "linear plasticity" and "colour plasticity".

Derain, Marquet and then Braque then joined the movement which was to be revealed to the public by the famous scandal of the 1905 Salon d'Automne. The liberation of the expressive power of colour in the first decade of the century is brilliantly represented by the three Fauve paintings from the Kaganovitch donation, *Pont de Charing Cross* by Derain and *Restaurant à Marly-le-Roi* and *Nature morte* by Vlaminck.

In the field of foreign painting, there were major gaps in the former collections of the Musée du Luxembourg and its annexe, the Jeu de Paume: the great artists who marked the break with the naturalism and symbolism of the previous century were totally absent. The Musée d'Orsay's purchasing policy aims to correct that state of affairs by purchases of major works, with a leaning towards landscape, a genre that is brilliant represented in its current collections of the Barbizon school and

∧
**Gustav Klimt
(1862-1918)**
Rosiers sous les arbres
c. 1905

Canvas
110 × 110
Purchased in 1980
R.F. 1980-195

^
Giovanni Giacometti
(1868-1933)
Vue de Capolago (Tessin)
1907

Canvas
51.5 × 60
Purchased thanks to
M. Philippe Meyer, 1997
R.F. 1997-15

Impressionism. The evolution of the art of painting over half a century can thus be clearly perceived by visitors. The painter Gustav Klimt, a major figure in the Vienna Secession founded in 1898, is now represented by *Rosiers sous les arbres*, one of the ten landscapes he painted between 1905 and 1910. This picture, in the seldom used square format, demonstrates the apogee of the decorative trend of the Vienna Secession, with its continuous network of leaves, fruit and flowers filling the surface of the canvas to the detriment of any spatial effect, which is deliberately abandoned. The Swiss painter Giovanni Giacometti uses a complex interplay of surfaces with lines running in different directions in his *Vue de Capolago (Tessin)* of 1907 to conjure up a landscape of fields, chalets and mountains. Only the silvery lake in the centre, with its pale pink reflections, is treated as a flat tint.

It is interesting to compare this radically new approach with a virtually contemporary work, *La Pointe d'Andey*, a rare Savoyard landscape by Ferdinand Hodler, the great symbolist painter and minstrel of the heroes of Swiss history. His robust technique gives daring depth to this view of blue mountains leant rhythm by the lines of clouds, in marked contrast to the narrow band of yellow and green landscape punctuated by scattered trees which forms the foreground.

>
Ferdinand Hodler
(1853-1918)
La Pointe d'Andey, vallée de l'Arve (Haute-Savoie)
1909

Canvas
67.5 × 90.5
Purchased in 1987
R.F. 1987-31

<
**Cuno Amiet
(1868-1961)**
Paysage de neige, also
known as *Le Grand Hiver*
1904

Canvas
198 × 236
Purchased with the
participation of the Meyer
foundation and privately
sponsored patronage in
memory of Maurice and Betty
Robin, 1999
R.F. 1999-15

>
**Vilhelm Hammershøi
(1864-1916)**
Repos (30 Strangade)
1905

Canvas
49.5 × 46.5
Purchased with the
participation of M. Philippe
Meyer, 1996
R.F. 1996-12

∨
**Edvard Munch
(1863-1944)**
*Nuit d'été à
Aasgaardstrand*
1904

Canvas
99 × 103.5
Purchased in 1986
R.F. 1986-58

Bold composition also characterises *La Grande Neige* by Cuno Amiet, with a tiny skier in the centre of the great white expanse. The Scandinavian painters, lead by the Norwegian Edvard Munch who created a scandal in Berlin and Paris at the end of the 19th century, are more faithful to a directly discernible representation of everyday reality, to which they add an atmosphere redolent of expressionism, intimism and symbolism.

Lastly, the 1986 acquisition of an impressive pre-fauvist landscape by Munch was an important event for the Musée d'Orsay, in view of the rarity of this artist's work on the international market. Indeed, there is only one other painting by this great expressionist in the French national collections, at the Musée Rodin. In this way, the directors of the Musée d'Orsay are seeking to re-establish a proper equilibrium between the avant-garde French movements and those which developed concurrently abroad, leading to the same conclusions of expressionism and abstract art.

The holding of one-man shows devoted to turn-of-the-century Nordic artists, many of whom had come to Paris in their youth before making their careers in their own countries, has led to some real discoveries. Before the blue Stockholm nights of the Swedish painter Eugène Jansson in 1999, in 1997 we discovered the poetic world of the silent interiors of the Danish artist Vilhelm Hammershøi. The museum has just purchased Hammershøi's picture *Repos,* eminently representative of his discreet intimism and innovative way of looking at the world.

Index

(The figures in italics refer to illustrations)

Albert (prince), 27
Aman-Jean, 146
Amaury-Duval, *23, 59*
Amiet, 5, *164*
Anet (Claude), 156
Angrand, 108
Antigna, 9, 19, 40
Apollinaire, 115
Arc (Jeanne d'), 112
Astruc, *57, 60*
Aubert, 90
Avril (Jane), *108*, 110, 111

Bassiano (princesse), 156
Bastien-Lepage, *135*
Baudelaire, 42, 54, 55
Baudry, 19, *29*, 59
Bazille, 11, 15, *57, 58, 62*, 81, 85
Bellelli (Famille), *51*
Bellier (Jean-Claude), 20
Bénard (Mme), 159
Bénédite (Léonce), 12, 148, 149
Benjamin-Constant, *133*
Bénouville (Léon), 26
Berggruen, 95
Bernard, 20, 97, 116, *118,* 119
Bernard (Madeleine), *118,* 119
Bernheim de Villers, 19
Bernheim (Frères), 159
Bernheim (Gabrielle), 129
Bernheim-jeune, 155, 156, 158
Bernstein, 156
Besnard, 133, *138*
Bey, 42
Bing, 155
Bizet (Mme Georges), *138*
Blanc, *132,* 133
Blanche, *139*
Böcklin, 5, 20, *144,* 145
Boldini, 138, *139*
Bonheur (Rosa), 9, *46,* 47
Bonnard, 5, 19, *122, 123, 124,* 129, *154,*
 155, *158, 159, 160*
Bonnat, 19, *138*
Boudin, 16, *45,* 67
Bouguereau, 29, *30*
Bourdelle, 157
Bourgogne (Berthe de), 133
Boutaric (Mlle), 19, 119
Braque, 161
Breitner, 20, 136, *147*
Breton, 19, 40, *46,* 135
Bruyas, 42
Burne-Jones, 5, 20, *143,* 144, 145

Cabanel, 19, 29, *30,* 37, 59
Caillebotte, 11, 12, 14, 15, 60, *72,* 77, 81,
 90, 93
Caillebotte (Martial), 12
Cain, *134*
Camondo (Isaac de), 14, 60, 68, 75, 86,
 90, 93
Capet, 133
Cappiello, 19
Cappiello (Mme), 19
Carolus-Duran, *50*

Carpeaux, 50
Carrière, 12, *146*
Cassatt, 62, *80,* 158
Cassou (Jean), 15
Castagnary, 46
Cazin, 59, *136*
Cézanne, 5, 11, 12, 14, 15, 16, 20, 50, 68,
 69, *70,* 88, 89, *90, 91, 92, 93, 94, 95,
 96,* 97, 101, 119, *128,* 129
Champfleury, 25, 42, 54
Charigot (Aline), 83
Charpentier (Dr et Mme), 16
Charpentier (Mme Georges), 81
Chassériau, 8, *26*
Chauchard, 11, 33
Cha-U-Kao, *110,* 111
Chennevières (Philippe de), *9,* 11, 40, 132
Cheuvreul, 103
Chintreuil, *47*
Clemenceau, 11
Clovis, *132,* 133
Coolus (Romain), 159
Cormon, *134,* 136, *137*
Corot, 9, 10, 11, 14, 15, 36, 37, 40
Cottet, *148*
Courbet, 5, 8, 9, 10, 11, 15, 20, 23, *36, 37,*
 40, *41, 42, 43, 44,* 50, 55, 67, 85, 133,
 135, 148
Couture, *24,* 25
Cross, 20, *106, 107*
Cross (Mme), 107

Daubigny, 5, 9, 10, 37, 38, 48, *49,* 50
Daudet (Mme), 81
Daumier, 15, 16, *22,* 23, *37*
Davis (Edmund), 12
Decamps, 11
Degas, 5, 11, 15, *35,* 38, *51,* 62, *76, 77,
 78, 79,* 110, 116
Delacroix, 8, 9, 10, 11, 14, 20, 26, 27, *28,*
 29, *54,* 57
Delaunay (Elie), 29, 30, *31, 138*
Denis (Maurice), 5, 19, 119, 123, *126, 127,
 128,* 129, 152, 155, 156, *157*
Derain, 16, *161*
Detaille, 132
Devillez, 146
Diaz, 9, 37
Dieuhl, 110
Domecy (baronne et baron de), 114
Doncieux (Camille), 64
Doré, *130,* 131
Dubois-Pillet, 108
Duchâtel (comte), 29
Dupré, 37
Durand-Ruel, 37, 59, *72,* 141
Duret, 87

Emperaire, 93
Ensor, *145*
Eugénie (impératrice), 48

Fantin-Latour, 11, 12, 14, 53, *54,* 55,
 57, 58
Faure, 59

Fénéon, 108, 111
Ferrier, 133
Feure (de), *152*
Flandrin (Hippolyte), 19
Forain, 19
Français, *47*
Frédéric, 148, *151*
Fritel, 133
Fromentin, 47, *48*

Gabrielle, 81
Gachet (docteur Paul), 16, *101*
Gachet (Paul et Marguerite), 90, 93, 97,
 102
Garnier, *29*
Gauguin, 5, 15, 89, 97, 101, 112, 115,
 117, 118, 119, *120, 121,* 123, 124, 129,
 141, *152,* 160
Gautier, 29
Gavet, 38
Gebhard-Gourgaud (baronne Éva), 16
Geffroy (Gustave), *88,* 95, 96
Géricault, 8
Gérôme, *25,* 115
Gervex, 19
Giacometti, 5, *163*
Ginoux (Mme), *13, 101*
Gleyre, 57
Goldschmidt-Rothschild (Mme de), 16
Goncourt (de), 54
Gonzalès, 80
Gould, 124, 159
Goulue (La), 110, 111
Goya, 59
Grégoire V, 133
Grégoire de Tours, *132*
Guigou, 16, *45,* 50
Guillaumet, 47, *48*
Guillaumin, 101

Hammershøi, 5, 164, *165*
Hartmann (Frédéric), 38
Hartmann (Mme), 10
Haussmann, 73
Hayet, 108
Henry (Charles), 104
Hodler, 5, 12, *163*
Homer, 12, *147*
Huet, 20, *24,* 145
Hugo, 131, 134
Huysmans, 144

Ingres, 9, 20, 25, 26, *27,* 59
Isabey, 20

Jacque, 19
Jacquet (Mlle Thadée), *146*
Jarry, 115
Jansson, *150, 151,* 164
Jeantaud (Mme), *77,* 79
Jongkind, 16
Jourdain (Mme Roger), *138*

Kaganovitch (Max et Rosy), 16, 90, 161
Kahn-Sriber, 86, 101
Khnopff, 5, 20, *146,* 152
Klimt, 5, 12, 20, *162, 163*

Laroche (Jacques), 16
Laurens (Jean-Paul), *132*, 133
Laval, 116
Le Barc de Boutteville, 148, 149, 155
Legros, 19
Lemmen, 20, *108*
Lévy-Dhurmer, *153*
Lhermitte, 19, *136*
Liebermann, 136, *137*
Loiseau (Ivan), 146
Louis XVIII, 9
Louis-Philippe, 8, 36
Loynes (Mme de), *23*
Luce, 20, 108
Lugné-Poë, 123, 156
Lung (M. et Mme Frédéric), 16
Lutèce Foundation, 19
Lwoff (Mme), *139, 141*

Maillol, 123, *126*, 155
Maître, 57, 85
Makart, 34, *35*
Mallarmé, 11
Mancini, *135*
Manet, 5, *6*, 9, *10*, 11, 14, 15, 16, 20, 29,
 38, *52*, 53, 54, 56, 57, *59*, 60, 61, 62,
 64, 68, 80, 85, 91, 135, 139
Manet (Julie), *85*
Manet (Mme), 11
Manet (M. et Mme Auguste), *52*
Marquet, 161
Martin (Henri), 19
Matisse, 20, 29, 90, 160, *161*
Matsukata, 16
Mazois, 26
Meissonier, 11, 19, 32, 33, *131*, 132, 145
Meissonier (Charles), 131
Meissonier (Mme), 131
Mellerio, 129
Ménard, 19
Menzel, 136
Merson, 19, *133*
Meunier, 136, *137*
Meurier, *127*
Meyer de Haan, 116
Meyer (Fondation), 60
Meyer (Philippe), 85, 114, 120
Michel-Ange, 35, 144
Millet, 8, *9*, 10, 11, 14, 33, 36, *38, 39,* 134
Moch (M. et Mme Fernand), 101
Mollard (Eduardo), 16
Mondrian, 5, *153*
Monet, 5, 11, 14, 15, 16, 20, 21, 38, 45,
 54, 57, 62, *63*, 64, *65*, 66, 67, 68, 69,
 72, 73, 74, 81, *86*, 87
Monfreid (Daniel de), 120
Montesquiou, 138, *139*
Monticelli, *50*
Morbelli, *149*
Moreau, 5, 34, 35, 141, *142*, 144
Moreas, 141
Moreau-Nélaton (Étienne), 12, 14, 23, 59,
 60, 86
Morisot, *60*, 62, *80*
Mucha, 19, 153
Mucha (Jiri), 19
Munch, 5, 12, 20, *164*

Napoléon I^er, 33
Napoléon III, 26, 30, 42, 59, 134
Natanson (Alexandre), 126
Natanson (Misia), 160
Natanson (Reine), 19
Neuville (de), 19
Nicolas II, *48*

Osbert, *151*

Pailleron (Édouard), 138
Pasca (Mme), *138*
Péladan, 136, 151
Pelizza da Volpedo, 12, *148*
Pellerin (Auguste), 20, 90, 93, 95, 96
Perret, 156
Personnaz, 16, 71, 111
Petitjean, 108
Picasso, 115
Picot, 29
Pils, 19
Pissarro, 11, 12, 14, 15, 16, 20, 50, 59,
 69, 70, 71, 75, 83, 89, 93, 101, 108,
 115, 116
Pissarro (Lucien), 108
Polignac (princesse de), 16, 159
Pommery (Mme), 10
Poussin, 25
Proust, *139*
Puvis de Chavannes, 11, 12, *34*, 107,
 123, 126, 132, 133, *140, 141*, 144,
 145, 148, 151

Quinn, 102

Ranson, 123, 129
Raphaël, 35, 59
Ravier, *50*
Redon, 5, 16, *18*, 19, 20, 89, *112, 113,
 114*, 129
Redon (Mme Ari), 19, 112
Regnault, 29, 30, *31*, 132
Renoir, 5, 11, 12, 15, 19, 20, 29, 57, 62,
 68, *69, 81, 82, 83*, 84, *85*, 86, 89, 158
Ribera, 32
Ribot, *32*, 146
Rimbaud, 54
Rimsky-Korsakov (Mme Barbe de), 29
Robert-le-Pieux, *132*, 133
Roll, 148
Rood, 103
Rouart (Henri), 38, 60
Rousseau (Henri, le Douanier), 16, 114,
 115, 116
Rousseau (Théodore), 9, *37*
Roussel, 123, *128*, 129, *155*, 156, 157
Roy, 116

Sainte Geneviève, 132, 133
Samary (Henry), 110
Sargent, 19, 138, 139
Satre (Mme), *116*
Schuffenecker, 116, *118*
Segantini, 12, 149
Séguin, 116

Serov, *139*, 141
Sert (Misia), 160
Sérusier, 19, 20, 116, *119*, 123, 129
Sescau, 111
Seurat, 15, 16, 89, *102, 103*, 104, 108,
 149, 152
Signac, 20, 29, 102, *104, 105*, 107, 161
Signac (Ginette), 107
Signac (Héloïse), 107
Sisley, 11, 12, 14, *67*, 68, *75*
Société des Amis du Louvre, 15, 16
Société des Amis du Luxembourg, 19, 146
Société des Amis d'Orsay, 20
Stevens (Alfred), *45*
Strinberg, 20
Stchoukine, 161
Stuck, 20, *145*

Terrasse (Charles), 20
Terrasse (Claude), 20, *129*
Thiéry (Thomy), 10
Thomas (famille), 157
Thomas (Gabriel), 156
Tiepolo, 25
Tissot, 19, 50, *51*
Titien, 59, 86
Toorop, *152*
Toulouse-Lautrec, 15, 16, 89, *109, 110, 111*
Troyon, 19

Utrillo, 83

Valadon (Suzanne), 83
Valentin le désossé, 110, 111
Vallotton, 123, *128*, 129, 155
Van Gogh, 5, *13, 14*, 15, 16, 48, 50, 89,
 97, 98, 99, 100, 101, 102, 116, 160
Van Gogh (Théo), 97, 101
Van Rysselberghe, 20, *108*
Van Rysselberghe (Mme Théo), *146*
Velasquez, 32
Verlaine, 54, 146
Véronèse, 25
Victoria (reine), 27
Vinci (de), 35
Vlaminck, 161
Vollard, 116, 120, 123, 129
Vollon, 19
Voragine (Jacques de), 30
Vuillard, 19, 123, 124, *125*, 126, 129, 155,
 156, 157, 159

Wagner (Otto), 81
Weerts, 19
Whistler, 5, *11*, 12, *53*, 54, 59, 139
Wilde, 111
Wildenstein (Daniel), 20, 124

Zola, 57, *59*, 60

Photographic Credits

Photoengraving
Offset Publicité, Saint-Maur-des-Fossés

Printing
Imprimerie Mame, Tours
Printed in France

March 2006
Dépôt légal
November 2003